ANDALUSIA

EVERGREEN is an imprint of Benedikt Taschen Verlag GmbH

© for this edition: 1999 Benedikt Taschen Verlag GmbH
Hohenzollernring 53, D–50672 Köln
© 1998 Editions du Chêne – Hachette Livre – L'Andalousie
Under the direction of Michel Buntz – Hoa Qui Photographic Agency
Text: Éliane Faure
Photographs: Christian Sappa/Hoa Qui
(except: pages 21, 63 (bottom), 77, 81, 82, 83, 87, 96, 104, 105, 151, 152 (left and bottom right) Philippe Body;
pages 84, 85, 86, 92, 148, 149 Thierry Borredon; page 150 G. Bosio;
page 93 Jacques Bravo; page 141 (right) Delacourt; page 141 (bottom left) Michel Denis-Huot;
pages 94, 95, 116, 117 J. F. Lagrot-Arenok; page 80 Reimbold-Kal; pages 27, 91 Michel Renaudeau;
pages 51, 56, 57 (left), 111 (top) Philippe Roy; page 19 De Saint Ange; page 153 Marc Torres;
pages 78, 79, 88, 89, 103 Christian Vaisse; page 15 Christophe Valentin; page 47 (bottom left) De Wilde;
pages 8, 9 Zefa-Kotoh; pages 152 (top right), 154, 155 Zefa-Raga; page 74 Zefa-Rossenbach;
Photographs supplied by the Hoa Qui Photographic Agency.)
Layout: Roger Donadini
Map and illustrations: Jean-Michel Kirsch
Editor: Corinne Fossey
Cover design: Angelika Taschen, Cologne
Translated by Simon Knight
In association with First Edition Translations Ltd, Cambridge
Realization of the English edition by First Edition Translations Ltd, Cambridge

Printed in Italy
ISBN 3-8228-7063-3

ANDALUSIA

Text ÉLIANE FAURE
Photographs CHRISTIAN SAPPA

EVERGREEN

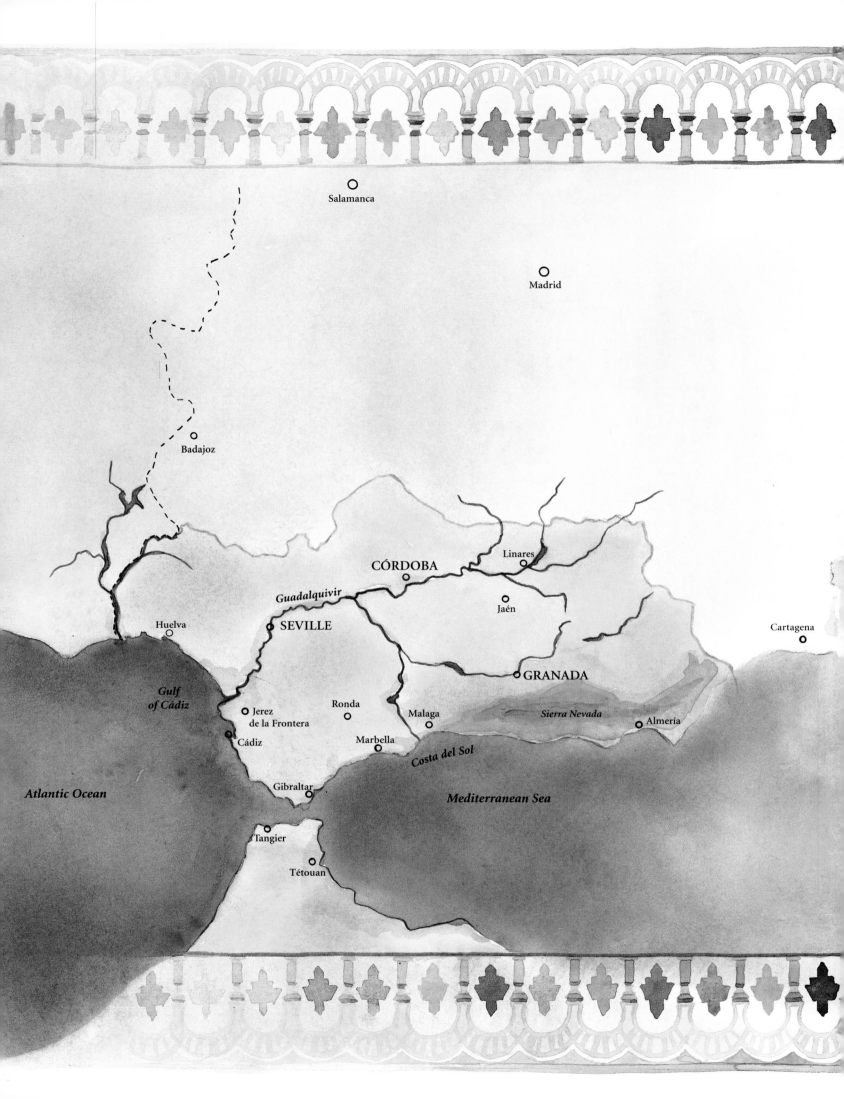

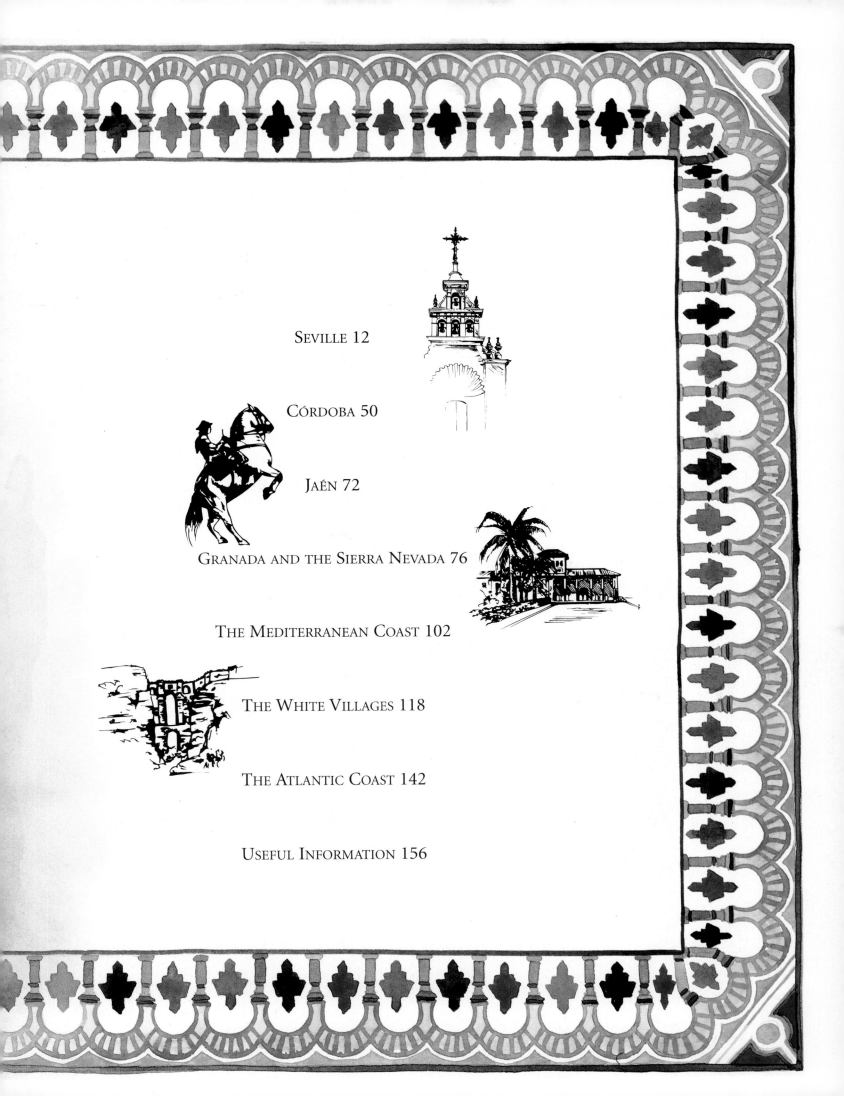

The ochre of the soil, the pitiless blue of the sky, the green of the olive trees, the white of the houses. Seville, Córdoba, Jaén, Granada, Almería, Málaga, Cádiz, and Huelva. Four colours and eight provinces compose this southern land at Europe's end. On the other side of the Straits of Gibraltar, beyond the rock-bound British enclave, lies Africa, where the ramparts of Andalusia are matched by the Rif Mountains of Morocco.

The 800-km (500-mile) coastline, fronting both the Mediterranean and Atlantic, has allowed free entrance to all the forces that have contributed to Spain's glory, or precipitated the country into chaos. The Moors crossed the 15-km (9-mile) Straits to establish a brilliant civilization, which lasted nearly eight centuries. At the time, Christendom was only just beginning to stir from its medieval torpor. Andalusia and the caliphs of Córdoba bequeathed us philosophy and medicine, and especially arabic numerals and algebra, which made such a vital contribution to the science of navigation. In the decades following the Reconquest by the Catholic kings, it was on the strength of this legacy that Columbus and Magellan set sail from Sanlúcar de Barrameda. As a result of their epic voyages, they proved that the earth was round and discovered a new continent, America, the dominant force in modern geopolitics. By sea again, from the Canary Islands and Morocco, General Franco, assisted by his Italian and German fascist allies, organized the nationalist rebellion of July 1936, eventually overcoming republican resistance. The centralizing Francoist dictatorship lasted thirty-six years, from 1939 to 1975. Everywhere, the regime reintroduced the system of *latifundios*, large landed estates that had been broken up during the agrarian reforms of 1932. And apart from constructing the odd road or bridge, and allowing the beginnings of tourist development on the Costa del Sol, he overlooked the potential of Andalusia. Not until the constitution of 1978 was the south's separate identity restored. In December 1981, Andalusia was granted autonomous status. The region is now governed by a parliament of 109 deputies, elected every four years, who meet in Seville, the regional capital.

But despite the dynamism of its wine-growing sector and fishing ports, which net 40% of Spain's total catch, depression in agriculture and heavy public indebtedness (8.6% of GNP) have put the brakes on economic growth. Unemployment is endemic, affecting 30.6% of the working-age population; though the rate varies from province to province, it is 10% higher than the already high national average. The olive harvest provides barely four months' work a year, while the production of vegetables and cereals is constrained by the common agricultural policy or merely provides precarious employment for casual labour. Tourism, now regarded with some suspicion because of its destructive fondness for concrete, also creates work, but only on a seasonal basis – despite the region's past glories and diverse landscape, and the fact that the sun shines 325 days a year. The region accounts for one fifth of Spain's income from tourism.

As for the economic stimulus expected from the 1992 Universal Exhibition in Seville, for the present its only fruit has been some much-needed road and rail infrastructure. The result was that in Andalusia, as in the rest of Spain, the electors took it out on local boy Felipe González's left-wing PSOE, though without disowning his party completely. The long-awaited Andalusian economic miracle is still around the corner. And with over seven million mouths to feed on a territory of about 88,000 km² (approx. 33,976 sq. miles) – much the same as in neighbouring Portugal – emigration has long been a fact of life for the region's inhabitants. It is a terrible wrench for the exiles, so attached to the staggering beauty of their native soil – their land rural yet festive, devout yet pagan, proud yet warm-hearted, conservative yet tolerant.

And not the least of its virtues is that it constantly overturns all certainties and generally accepted ideas. It is not backward, or flat, or arid. In the north, it is separated from Castile by the verdant cork-oak forests of the Sierra Morena. The Sierra de Cazorla, to the east, is the source of the Guadalquivir, which waters Córdoba and Seville before forming a majestic delta and losing itself in the Atlantic at Sanlúcar. The "great river", as the Moors called it, crosses the region from east to west, its graceful meanders forming a fertile alluvial

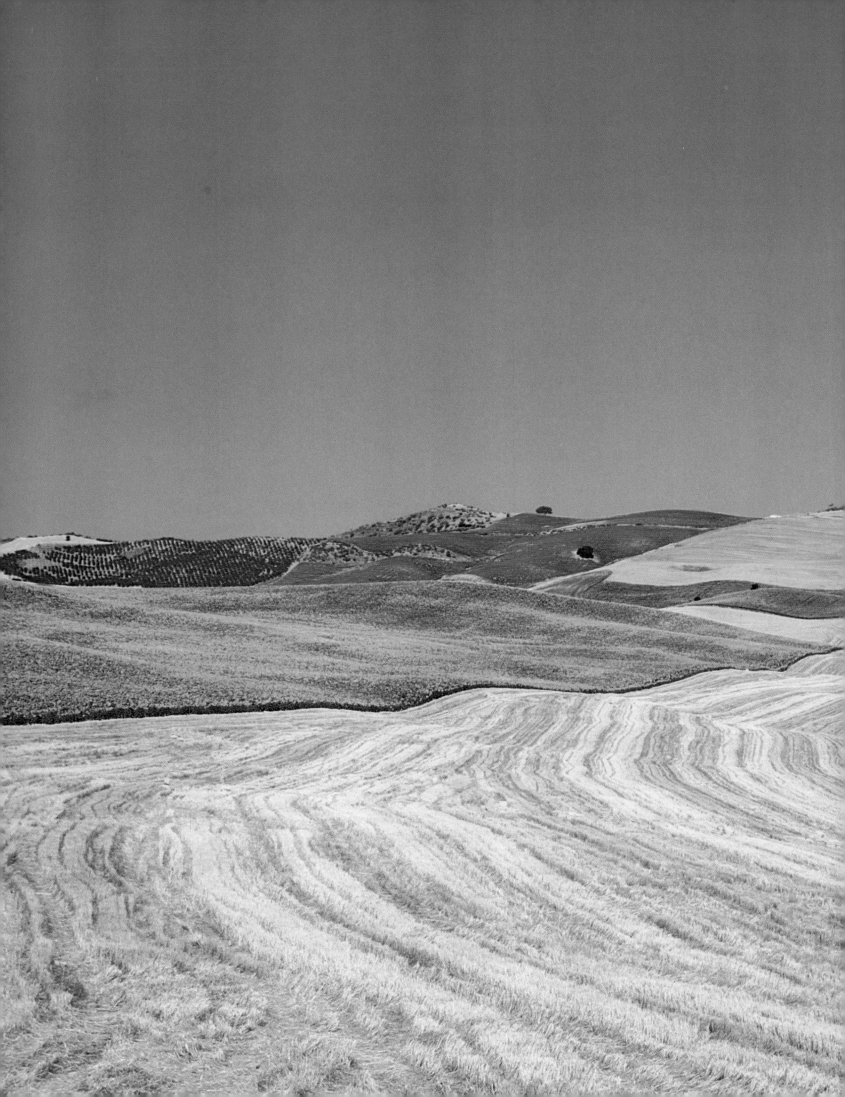

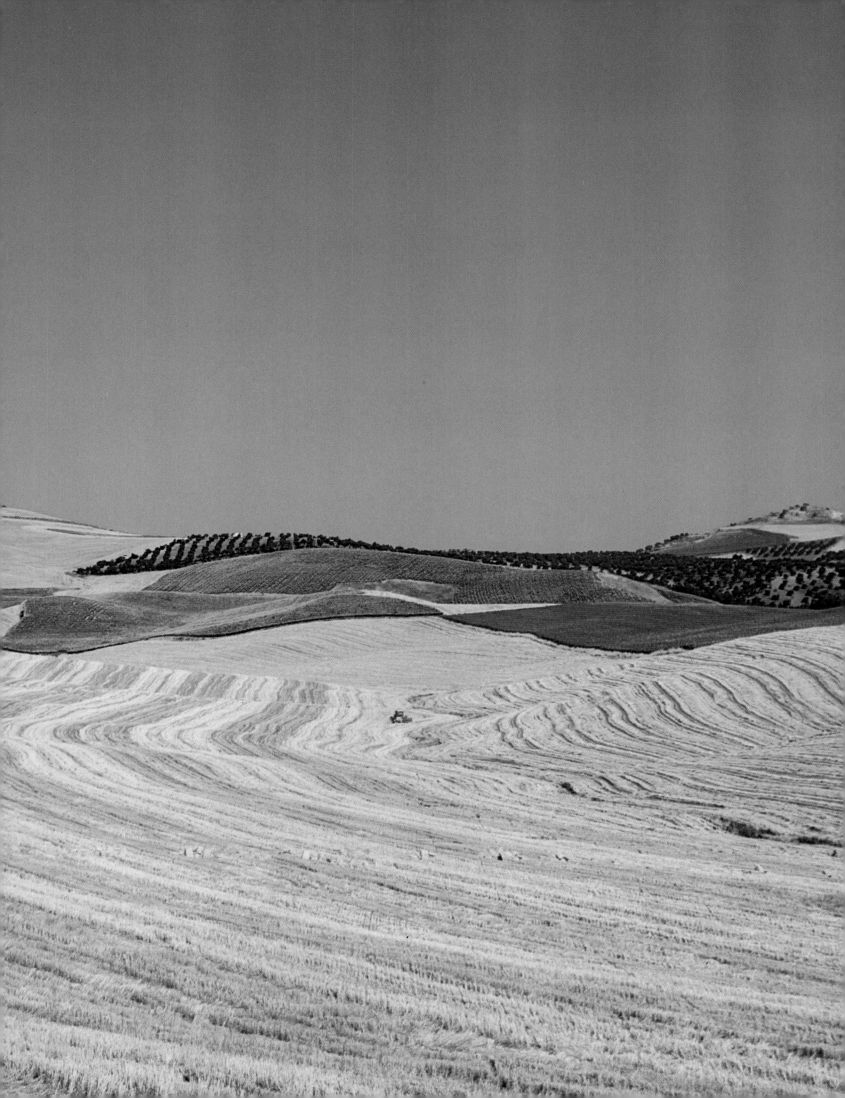

valley more than 600 km (373 miles) in length. In the south, the land has been pushed up to form the Sistema Penibetico, a last rampart against the Mediterranean. Here skiers revel in the perpetually snow-covered slopes of the Sierra Nevada, culminating at 3,478 m (11,410 ft) in the Pico Mulhacén, which forms the backdrop for the Alhambra Palace, a jewel of Islamic architecture. But perhaps the most fascinating feature of this unpredictable topography is the parched crust of the Tabernas Desert, a landscape worthy of a classic cowboy film. Finally, in the hinterland between the Atlantic and Mediterranean rises a well-watered mountainous area furrowed by rivers, where whitewashed villages cling to the clifftops like white horses run aground on tortured reefs.

There is not one Andalusia, but a number of quite distinct environments. The geological quintessence of Spain, the region includes more than twenty nature reserves, where the local authorities are trying to implement a much-needed conservation policy. Their efforts are of course motivated in part by an awareness of the mistakes made on the coast, but they are still not sufficient to avoid disasters such as the recent pollution of the Coto Doñana national park. Nevertheless, with 15,000 km² (5,790 square miles) or 17% of its territory protected, the region has made great strides, and has shown sensitivity to the need to protect the environment. There is the pleasure of discovering 150 species of plant specific to this area, and the largest colony of lynxes still to be found in Europe.

Where the urban landscape is concerned, Seville, Córdoba and Granada combine the delights of an Arab garden, in which the sharply defined shadows of palm trees complement geometrical box hedges, the refinement of mudejar *azulejos* (glazed coloured tiles of the post-Islamic period) and the flamboyant, gilded excesses of Baroque architecture.

Andalusia is a generous land whose inhabitants have made the best of the cultural heritage of each successive occupier. This surely proves the intelligence of a people who, despite a million summer love affairs, have remained shrewd and clear-sighted.

Seville's predominantly ochre façades are pierced by finely carved windows, whose wrought-iron grilles safeguard the privacy of the occupants.

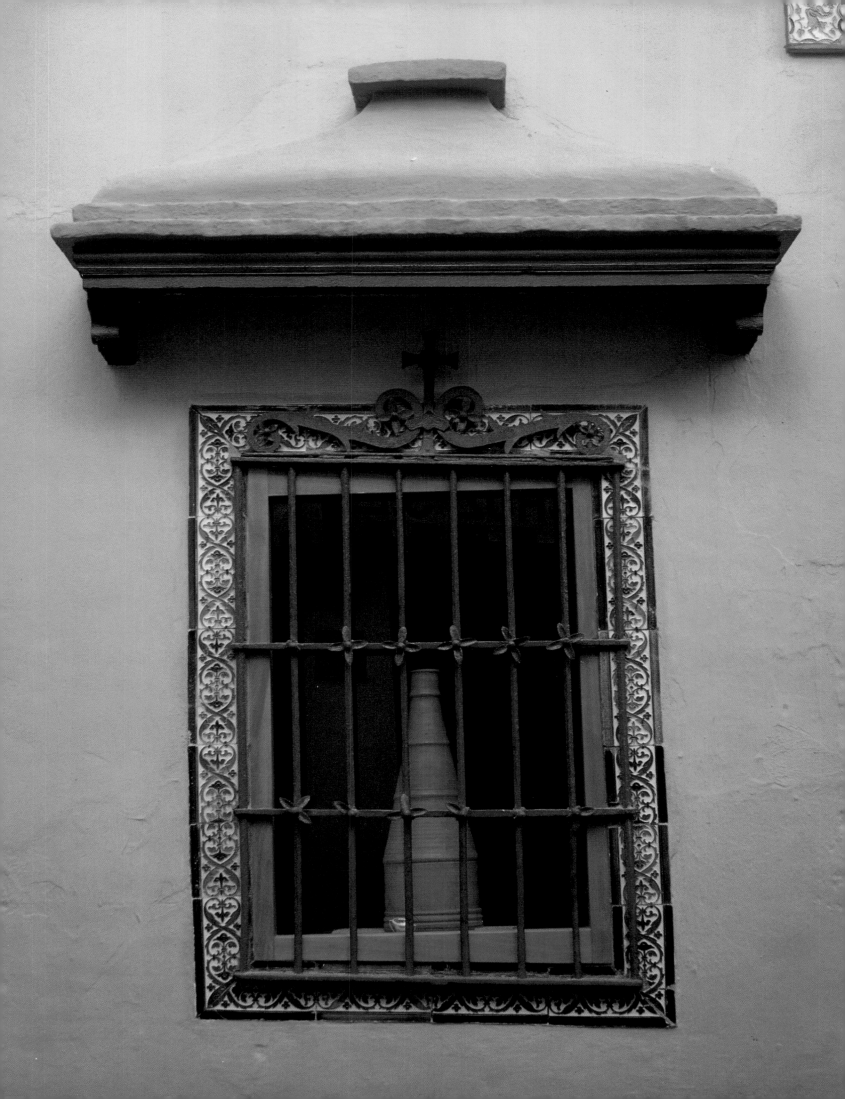

¡Quien no ha visto Sevilla

no ha visto maravilla!

He who has not seen Seville

has not seen a marvel!

SEVILLE

A vestige of the Almohad period, the Torre del Oro stands like a benevolent sentry on the east bank of the Guadalquivir. Defending the old harbour, it owes its name to the gilded mosaics of its upper storey.

The durable old saying will sometimes fall from the lips of a native *sevillano*, spicing up the bland conversation begun around the eight-o'clock glass of sherry. It is at this hour that the light of a sky bleached by the afternoon heatwave at last shows some tenderness in caressing the whitewashed, ochre, and burnt sienna façades, and discreet shadows come slanting in between the wrought iron of the balconies – a moment of grace, during which the inhabitants of this marvellous city will be found relishing its every feature: churches and fountains, secluded squares and alleyways, parks and cafés, *tapas* and Manzanilla. The purpose of this typically Mediterranean activity is to enjoy a *paseo* after leaving the office, making the most of the slight breeze before dinner time. On the edge of the city centre and the Macarena district, the Calle Sierpes channels the daily flow of strolling humanity, a broad sample of Sevillian society. Two faintly delinquent teenagers, or perhaps just gypsies (which for some people amounts to the same thing), pay a clumsy compliment to a brunette in a tight-fitting black trouser suit. Along the Paseo Colón, the cooler air stirred by the Guadalquivir works its magic on a wilting business executive. Off comes his tie, and his lips express a brief sigh of satisfaction. More relaxed, he decides to take a

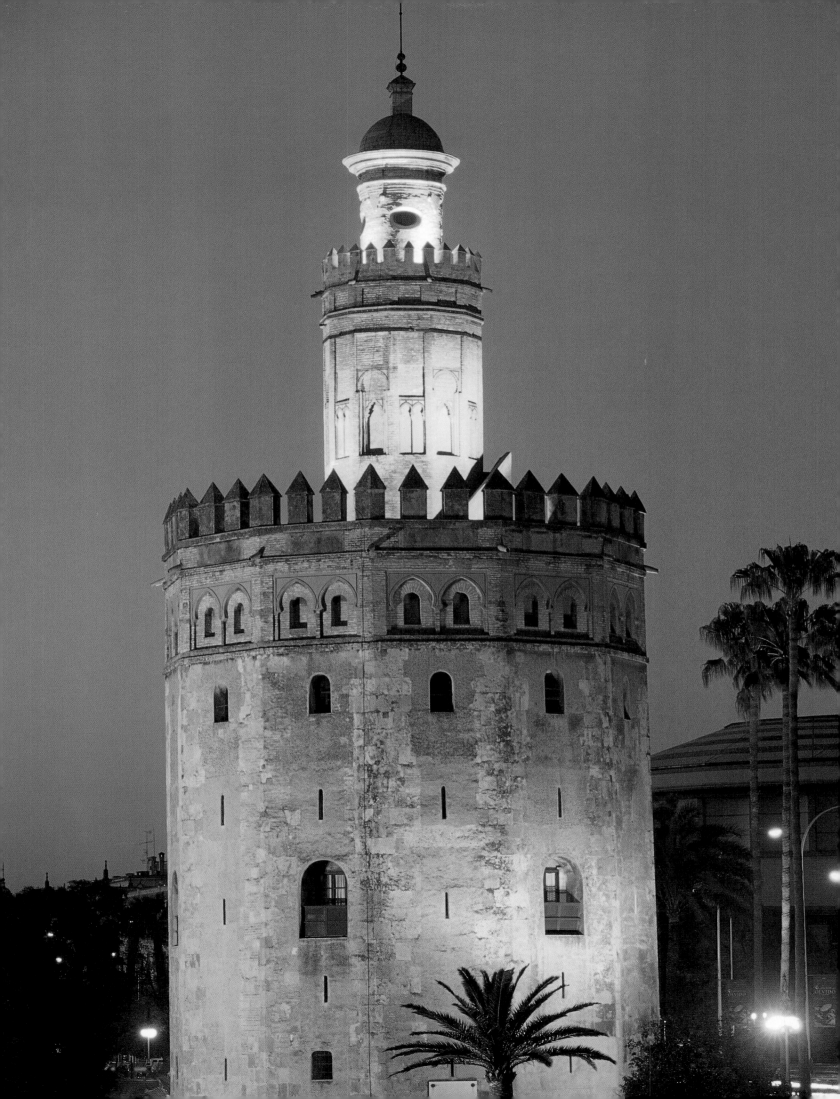

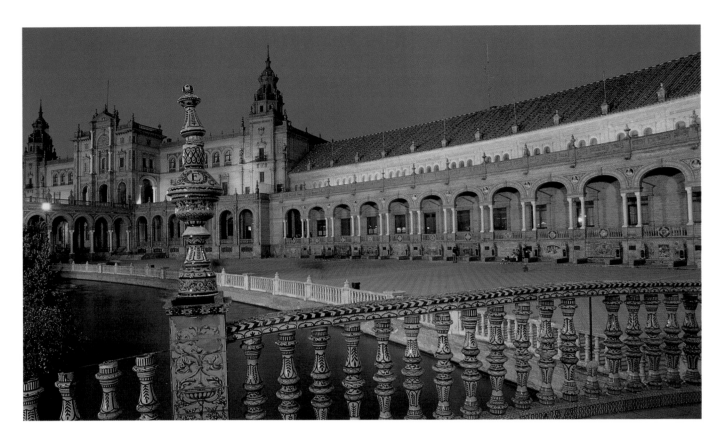

The Spanish Pavilion, set in the María Luisa Park, is the most significant legacy of the 1929 Ibero-American Exhibition. Architect Aníbal González designed it with an arcaded gallery and a 500 m-long (1,640 ft) canal.

stroll. Passing the Torre del Oro, which guarded the harbour built by the Almohads, then served as a safe-deposit box for the treasure unloaded from the conquistadors' galleons, he soon reaches the Baroque entrance to the sleeping Maestranza bullring, strangely silent after the unrestrained passion of the great April *corridas*.

In the evening hour, feverish Seville takes a short break, before stamping the night away in the flamenco bars of the Triana on the other side of the *Wad el Kebir*, the great river, as it was known to the Moors. In the rays of the setting sun, the graceful metal arches of the Isabel II Bridge are haloed with straw-coloured light, in striking contrast with the lumpish new tower of the Expo 92 complex, a futurist landmark on the city skyline. Over on the west bank, on the island of the Cartuja, time has caught up with the old Carthusian monastery of Santa María de las Cuevas. The peaceful Cartuja, Seville's charterhouse, built above flood level in 1401, is now surrounded by the Palace of Discoveries, the Technology Park and the sphere of the Omnimax Cinema. No doubt it

is a fitting destiny for a hermitage which set aside prejudice to open its library to Columbus, and inspired him with the necessary boldness to explore the Caribbean. The Cartuja no longer even houses its celebrated ceramics factory, the activity for which the Triana was once best known. However, the district still has plenty of workshops producing terracotta, pottery, and multicoloured earthenware. In Calle San Jorge, the disdainful expression of a 60 year-old British tourist wipes the good-natured smile from the face of an *azulejos* seller, weary of rearranging his glistening bric-à-brac. In Calle Betis, down by the river, the waiter in a *freiduría* (fried-fish establishment) enjoys a brief respite, surveying the opposite bank while a customer hesitates over the bill of fare. Betis is undoubtedly an unrivalled vantage point for viewing the city centre. And from the San Telmo footbridge, where the silhouette of two embracing students glides off towards the university, you can see the old Fábrica de Tabacos which, if we are to believe Mérimée, once employed a female worker by the name of Carmen.

Spectacular mosaics representing historical events associated with different Spanish towns adorn the hemicycle of the Spanish Pavilion. Following pages:
The setting sun casts an orange veil over the Quadalquivir and the first lights glimmer on the Isabel II Bridge, which links the Arenal district with the Triana.

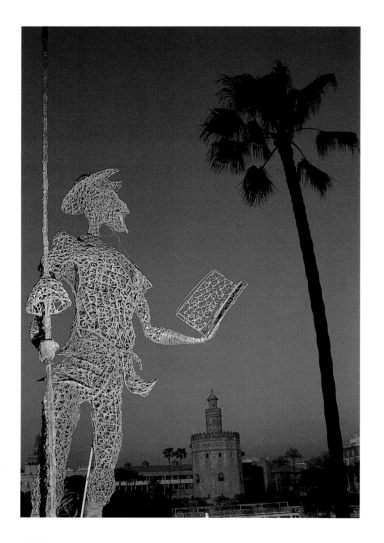

The silhouette of Don Quixote watches over the town where Cervantes wrote the Iberian peninsula's most celebrated literary work.
In Plaza Virgen de los Reyes, the delightful fountain with its devil's head and lanterns appears typically Baroque. In fact it was erected in the early years of this century.
Facing page:
Creating a cool oasis at the heart of the home, the fountain is a reminder of the Muslim fondness for ablutions.

Near the university, the greenest section of the east bank, weary tourists in rope-soled sandals are still wandering through the María Luisa Park, and latecomers hastily admire the sophisticated mosaic panels which adorn the hemicycle of the Plaza d'España, built for the 1929 Ibero-American Exhibition. Half an hour later, the same individuals, stomachs frustrated by the Spanish custom of dining late, will be seen pacing the narrow streets of the Santa Cruz district in the old city centre, to which they seem irresistibly drawn. While looking out for a restaurant terrace ready to welcome them, they gawk shamelessly through the wrought-iron gates of a private patio garden planted with orange trees.

Who cares? The city which spawned Don Juan, and launched its caravels around the globe to prove that the earth is round, is hardly going to be

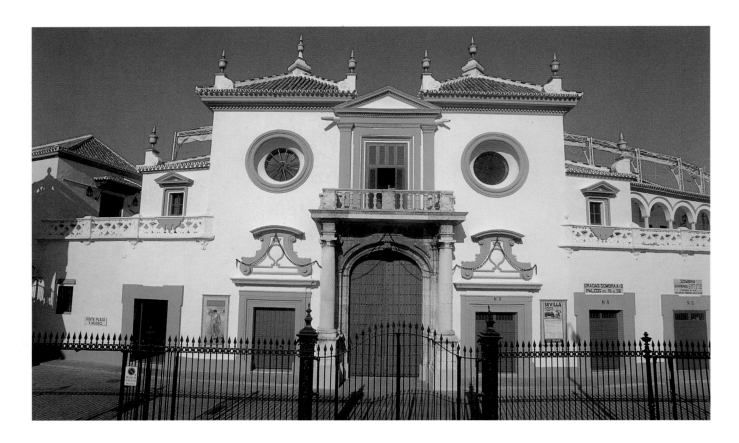

*T*he Baroque façade of the
Maestranza bullring has something
Mexican about it. Started in the
eighteenth century and completed
in the nineteenth, it is the setting
for bullfights between April
and October.

upset by so minor an impertinence. Seville takes life in its stride, simply, without inhibitions. Its hallmark is sincerity. We think of it as extreme during Holy Week and glimpse its fervour when a passing procession is stopped dead by the purity of a *saeta* sung spontaneously from an adjacent balcony. We find it rowdy and violent during the *feria*, when it explodes into carefree happiness in a mass of swirling skirts dancing the *sevillana*. There is something enticingly vulgar about its castanet shows, its fortune-tellers and its gypsy guitars; and yet something surprisingly sensitive, when the sad words of an improvized song come welling from the back room of a deserted *bodegón*. Seville is all these things: extravagance and subtlety, caricature and gentle suggestion. In a word, it is unaffected, like its people, having just that relaxed touch of class which makes every Sevillian a *señorito*. Centuries of cultural and religious cross-fertilization, of cohabitation and contrast, undoubtedly have something to do with it. And the modern city, owes its lifestyle, its distinctly Andalusian identity, to successive waves of occupants.

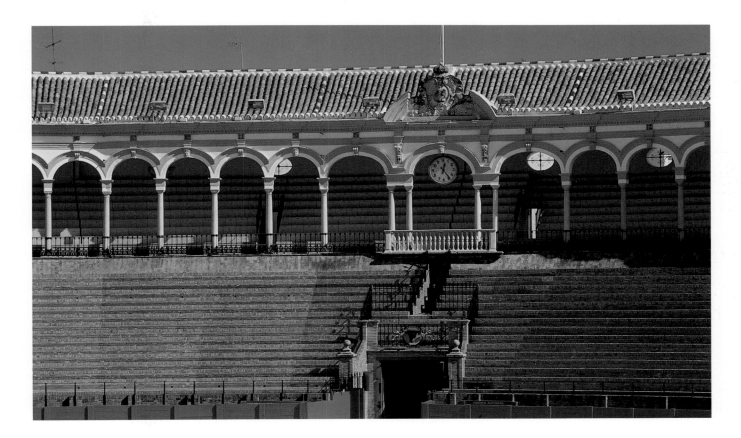

We can trace its history back to the mysterious kingdom of Tartessos (biblical Tarshish), founded on copper and silver mining, which reached its zenith around 800 BC. Then came all those invaders who crossed the straits, from North Africa or the Eastern Mediterranean, and made their way up the Guadalquivir: Phoenicians and Greeks, who arrived around 1110 BC; Carthaginians (550 BC); the Jewish Diaspora (300 BC); and the Romans, who first founded Italica nearby (206 BC), then Hispalis (45 BC), on the site of the modern city. In AD 322, the town became the capital of the Roman province of Betica, the Empire's bread-basket. Invaded by the Visigoths a hundred years later, it was subject for a time to Byzantine occupation, before finally submitting to more than five centuries of Muslim domination (712–1248). During this period, Seville superseded even Córdoba in importance, after the caliphate fragmented into thirty or so petty states – the Taifas – in 1013. It owes its lasting magnificence to the Almohad dynasty, whose rulers erected the immortal symbol of its faith: the famous Giralda, a mosque converted

The terraces of the Maestranza, one of the largest arenas in Spain, can hold up to 14,000 spectators. Before making their entrance, the 'toreros' collect their thoughts in the adjacent chapel.

into a cathedral by the Catholics. As the town's emblem, it adorns T-shirts, keyrings, and other tourist souvenirs.

Like all beautiful Andalusian women, Seville still has Moorish blood in its veins. And this exotic ancestry is very much emphasized in these days of regionalism, as a pretext for further distinguishing itself from once-dominant Castile. The Moorish heritage also finds an echo in the collective unconscious because of its association with religious toleration. Maybe it provides a way of exorcizing the sinister memory of long processions of hooded executioners, which would leave the Triana, where the Inquisition had its headquarters, for Plaza San Francisco, forever associated with the *auto-da-fé* and the martyrdom of those regarded as heretics.

Certainly, where architecture is concerned, Muslim influence is everywhere superimposed on the heritage of Christianity. And the Catholic kings were so envious of the caliphs that for two centuries after the Reconquest they faithfully copied their style of building. The

The narrow streets of the Triana district, a labyrinth of single-storeyed, whitewashed houses, attract many late-night revellers.
Seville's cafés have smart ceramic signs which were once produced at the Cartuja monastery.
The slightly insolent expressions of these young gypsies conceal the reality of their circumstances: they make a modest living selling flowers to passers-by.

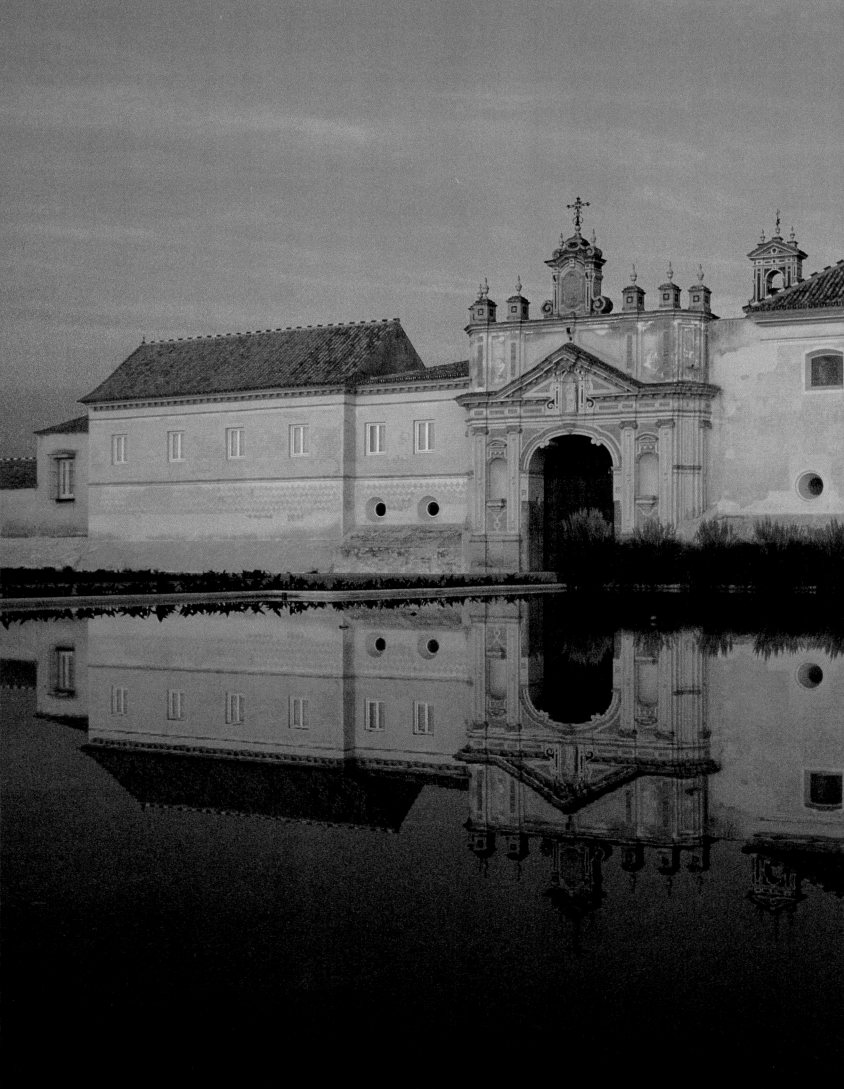

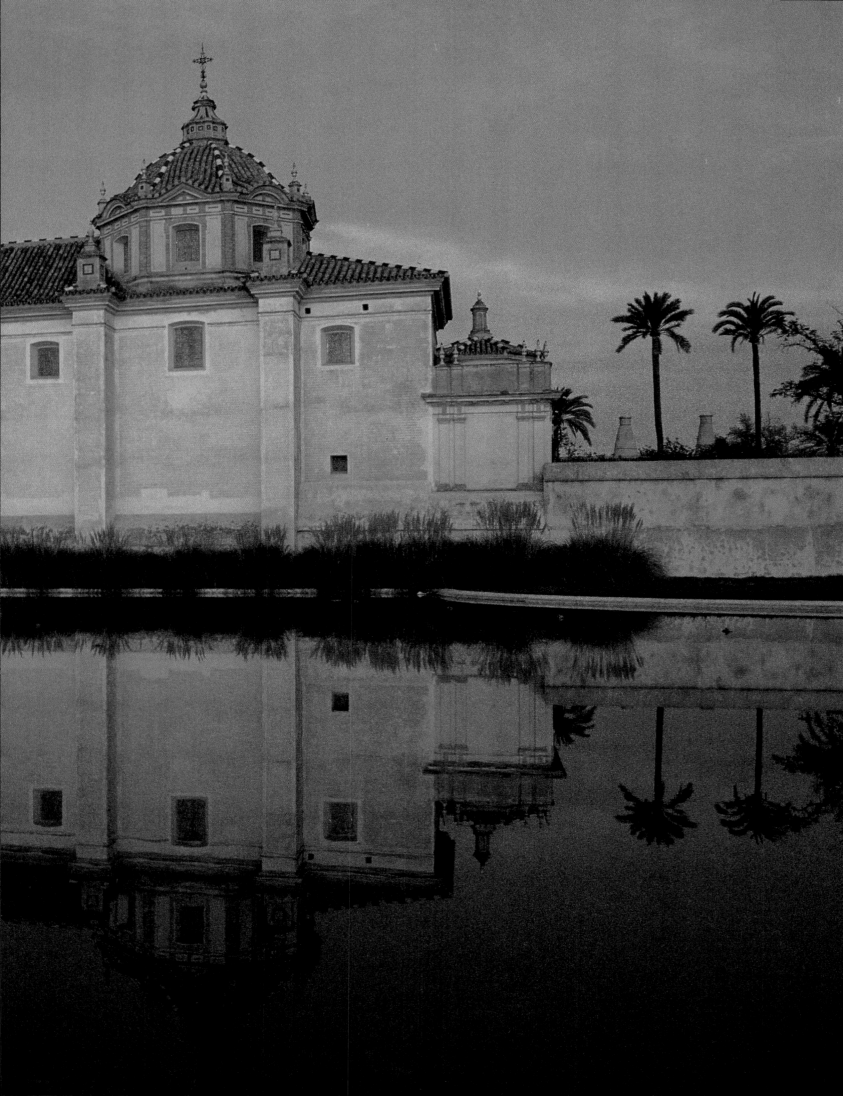

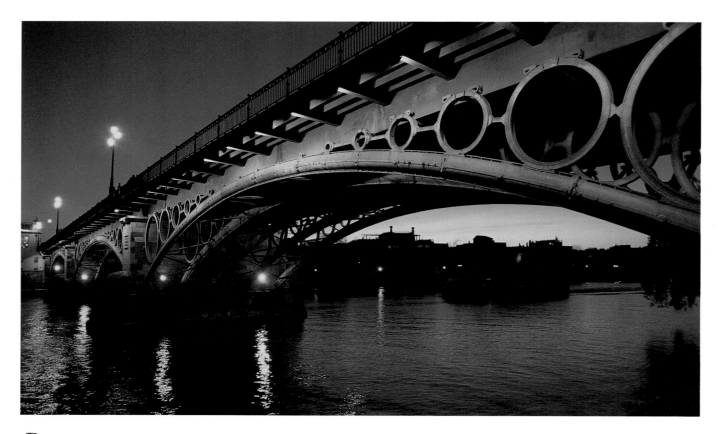

*P*revious pages:
Set in a bend of the river, the
Cartuja is the Carthusian
monastery which welcomed
Christopher Columbus when,
between expeditions, he came to
consult the occult texts in its library.
Above:
At night, the metal arches of the
Isabel II Bridge take on a bluish
tinge. Completed in 1845, it is the
city's oldest bridge.
Facing page:
Faithful to the Moorish style of
North Africa, the Moroccan
Pavilion, built for the Universal
Exhibition, harmonizes perfectly
with the Sevillian townscape, of
which mosaic decoration is a
recurring feature.

mudéjar style, as it is known, with its delicate gilded carving, forms a link between one era and the next. It is embodied to perfection in the Palacio Pedro I, in the heart of the Alcázar, which was decorated in 1364 by the most highly skilled Muslim craftsmen Granada and Córdoba could provide. Its wonders include the Hall of the Ambassadors and the Patio de las Doncellas. As you enter, there is a sense of trespassing on holy ground, your steps disturbed by the sudden coolness of the *azulejos*, your shoulders intimidated by the graceful, horseshoe-shaped arch of the entrance with its polychrome decoration.

As a distinct way of life, the *mudéjar* style carried over into the Christian era, fascinating such wealthy men as the Duke of Alba, who acquired the Palacio de las Dueñas, and the Duke of Medinaceli, to whom belonged the Casa de Pilatos. This residence, a folly intended to replicate the palace of Pontius Pilate in Jerusalem, is built around a main patio embellished with *azulejos* and stucco work, moulded using a technique which probably dates back to the thirteenth century. Not until the advent of the

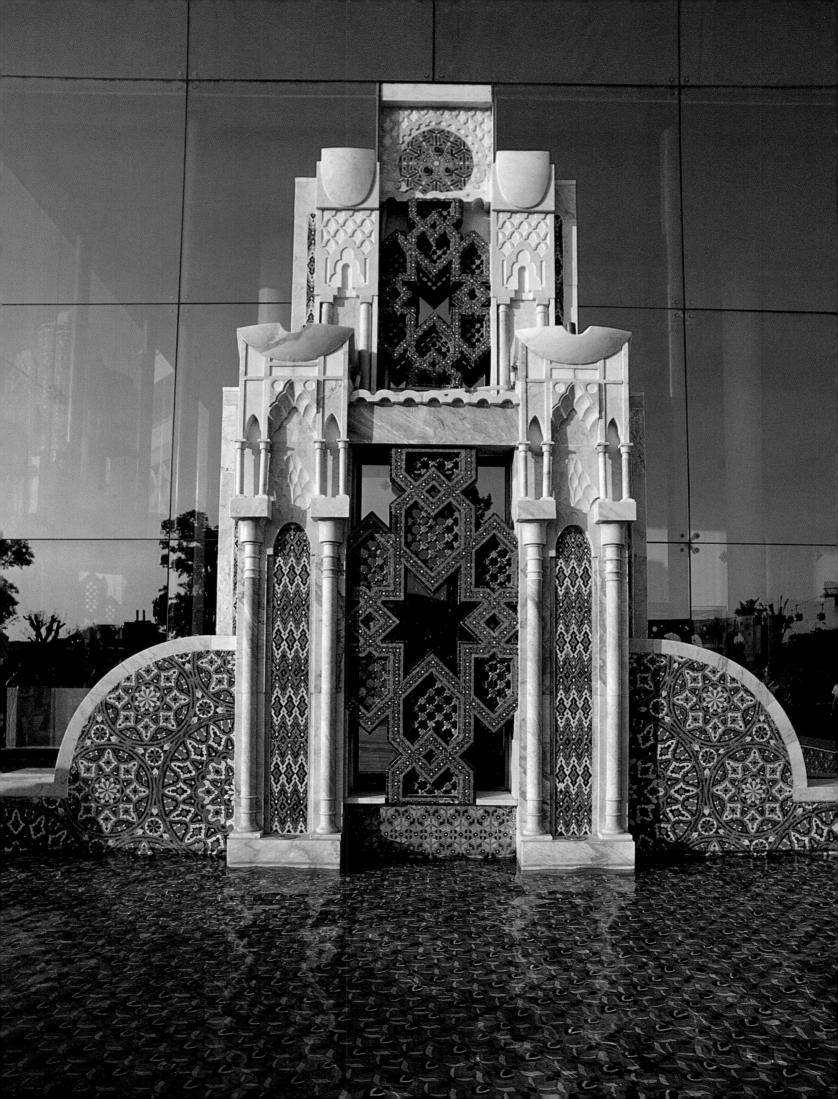

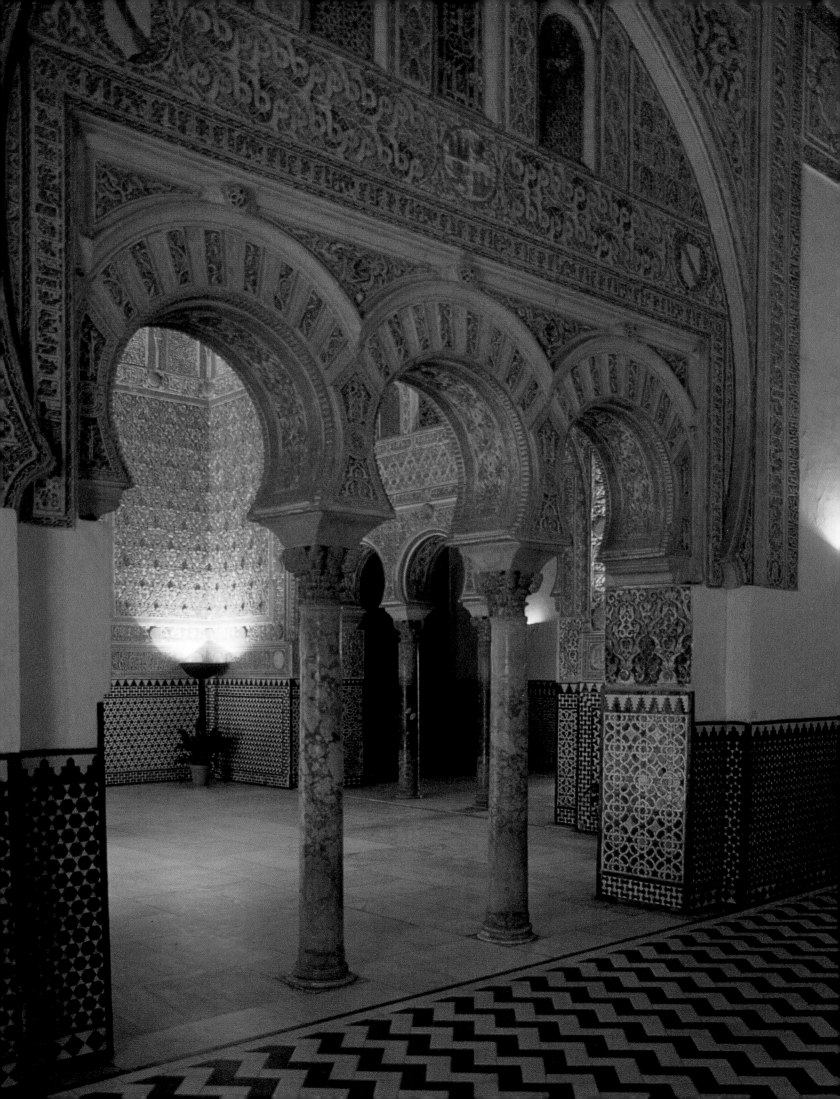

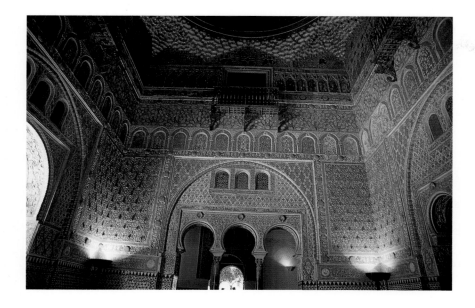

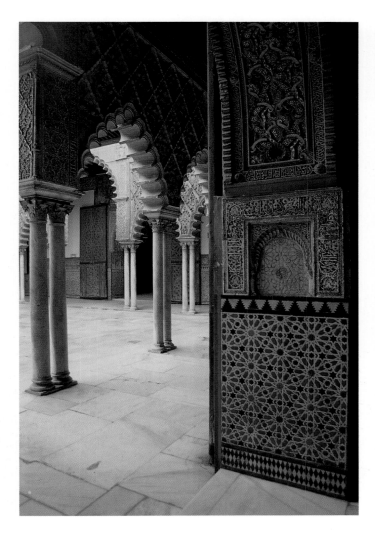

*T*he mudéjar-style entrance arches of the Real Alcázar, and the dome of the Hall of the Ambassadors, rival in refinement the mosaics of the Patio de las Doncellas.

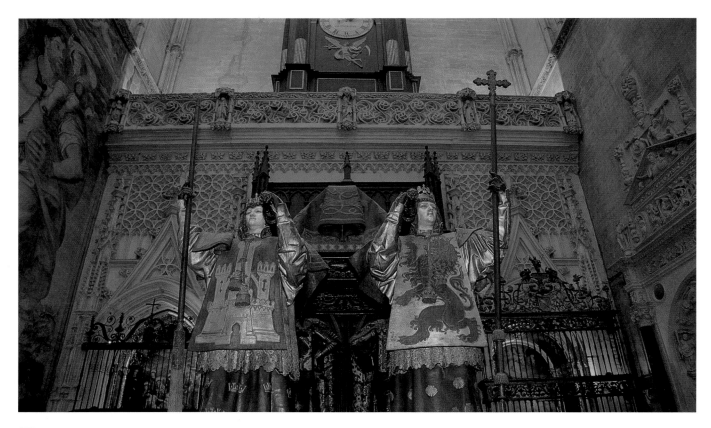

Beneath the Gothic vaults of the Giralda, the cathedral, lie the remains of Christopher Columbus, brought here from Havana in 1899. The bearer figures represent the kingdoms of Leon, Aragon, Castile, and Navarre.

Baroque, in the seventeenth century, did the *mudéjar* style fall from favour. From this period date the heavy staircase of the Museo de Bellas Artes and the pediment of the Hospital de la Caridad church, weighed down with ostentatious woodcarving and sculpture, in complete contrast with the Moorish delight in miniaturization. In both buildings there are paintings in a more sensitive style, by Bartolomé Esteban Murillo, Juan Valdés Real, Francisco Pacheco, José de Ribera, and Francisco de Zurbaran.

During Spain's golden age, the time of her expansion into the Americas, more extravagant influences were beginning to make themselves felt. Having completed the *Reconquista*, the Spanish monarchs, wanting to outdo the Moors, imposed the Gothic style and opened their doors to the Italian Renaissance. Silver flowed in throughout the sixteenth century, when the port of Seville was the obligatory gateway for the wealth of the Americas. Statuary imported from Genoa began to adorn windows and doorways, while chapels and altarpieces were gorgeously

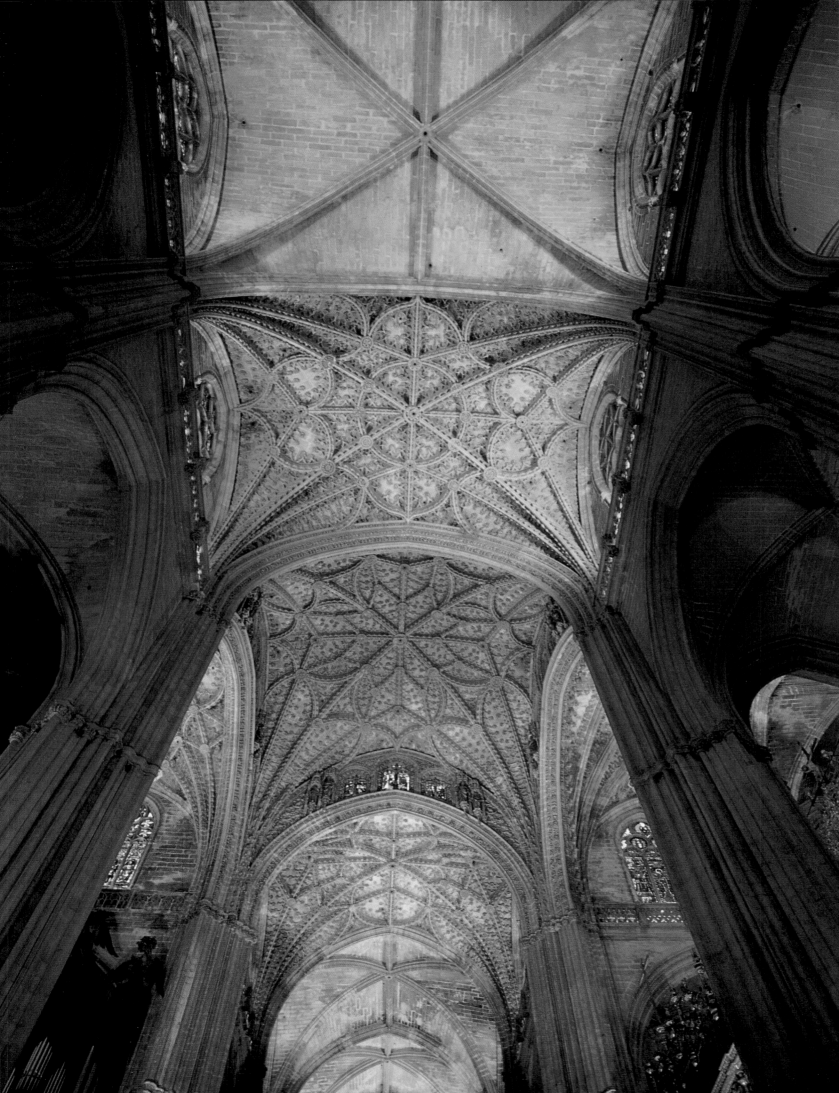

*T*he exterior and interior decoration of the city's cafés is
evidence of the sevillanos' talent for friendship,
shared around a glass of sherry and some tapas.

• Tapas •

Tapas are eaten as soon as the sun begins to go down, washed down with a cool Sevillian beer (a
Cruzcampo for example), as you stand in the shade at a bar counter. In the afternoon, a Manzanilla
sherry would be the drink of choice. The term *tapa* describes any hot or cold snack you nibble to stave
off the pangs of hunger: fried whitebait, squid, slices of salami, pieces of omelette, mini-kebabs of
gherkin, olive and red pepper, peanuts, and so on. You tend to end up eating a full meal without
realizing it, when all you really wanted was to tide yourself over until dinner time. But behind the
azulejos signs of an Andalusian bar, *tapas* time is also an expression of the openly convivial southern
Spanish lifestyle.

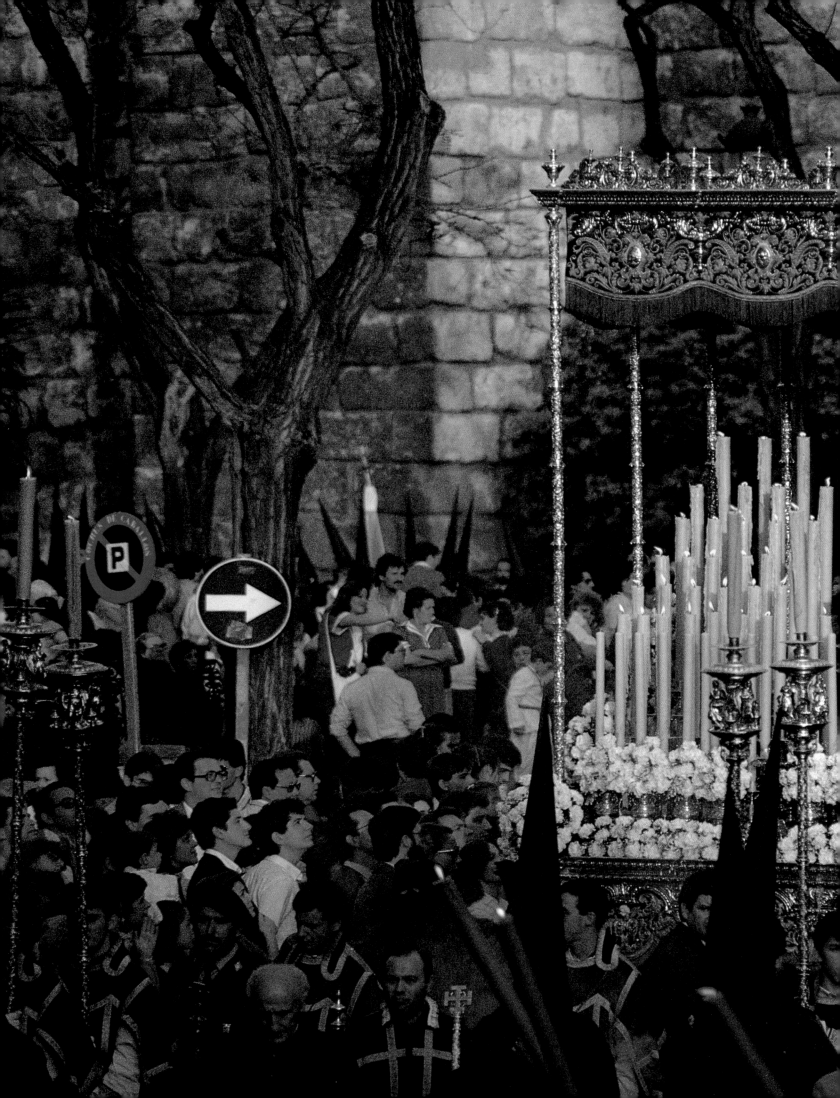

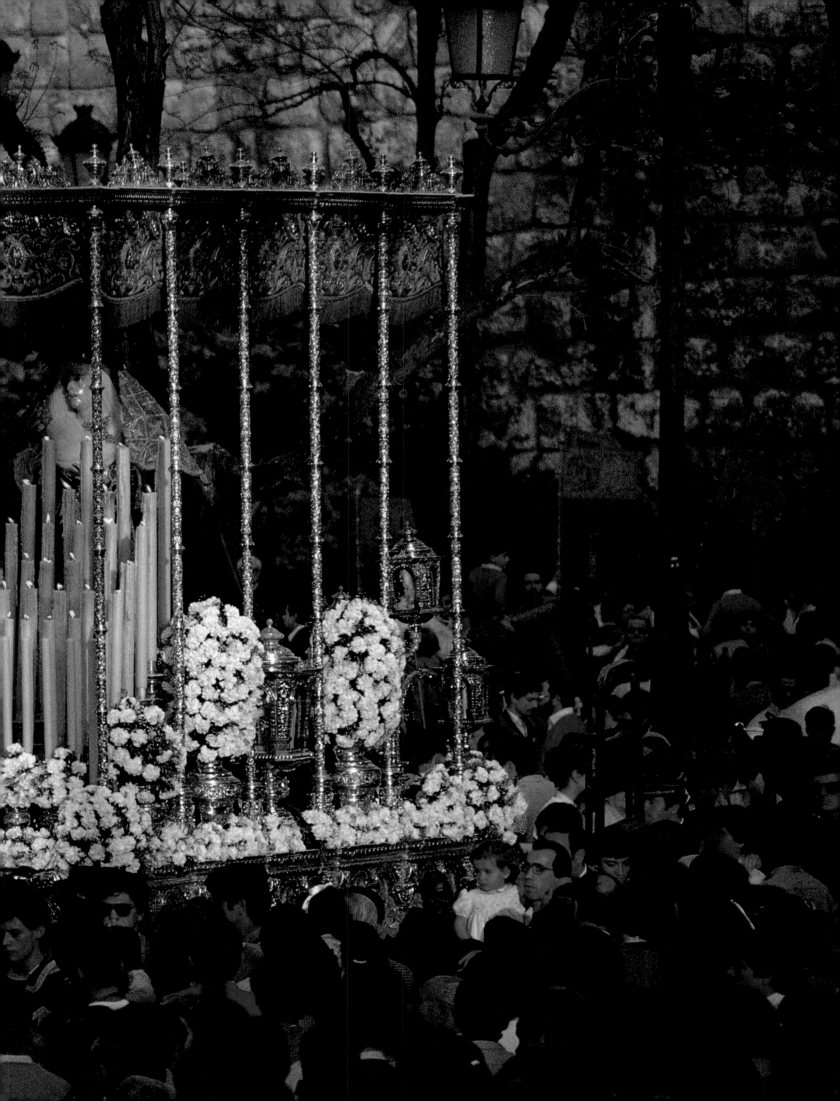

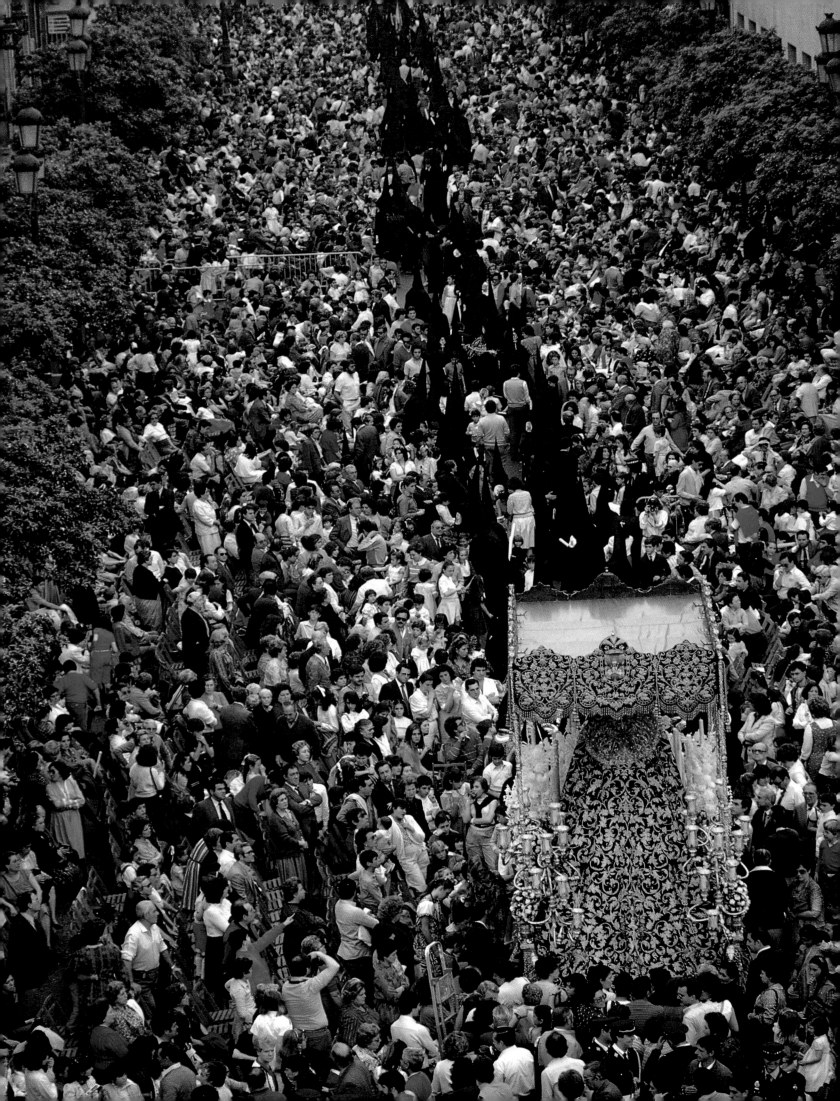

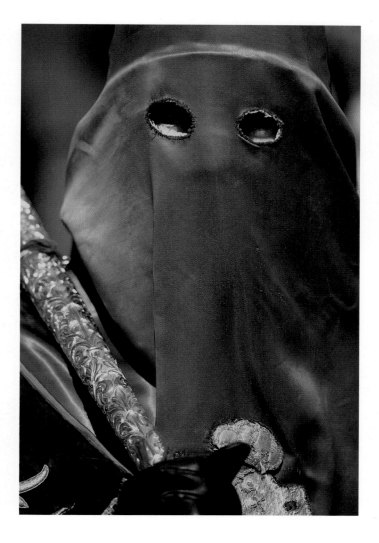

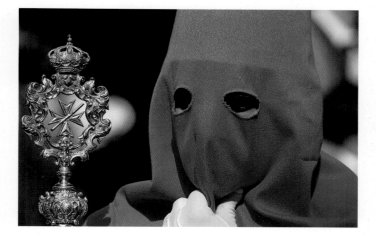

*D*uring Holy Week, between Palm
Sunday and Easter, crowds gather
along the route taken by the
processions. On Good Friday, they
venerate the effigy of the Virgen
de la Macarena.

*T*he procession is accompanied by lay penitents in black hoods,
members of a religious brotherhood.

• Religious brotherhoods •

In Seville, more than fifty *cofradias* are involved in celebrating Holy Week each year. No true *sevillano* would want to miss the events of the days between Palm Sunday and Easter – not even prisoners, two of whom once again escaped in 1997 to swoon, in the early hours of Good Friday, before the cart of the sublime Virgen de la Macarena! All week long, the brotherhoods, which have striven to excel in decorating the floats of Christ and the Virgin Mary, carry the sacred figures through the streets of the town, towards the cathedral. Walking with slow steps to the hammer beats of the black-robed *acatapaz*, dozens of *costaleros* (porters) grope their way along carrying the *pasos* (floats), which weigh several tons. The procession is flanked by hooded penitents, or *nazarenos*, wearing the costume of the brotherhood.

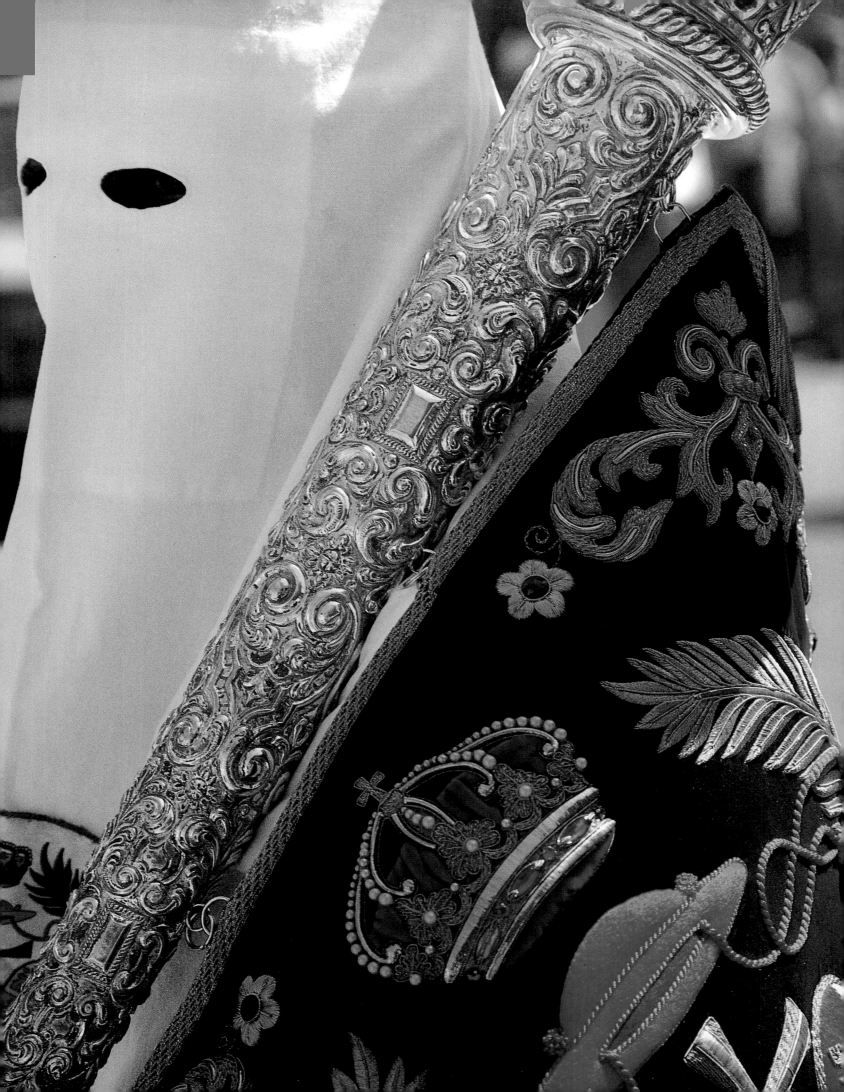

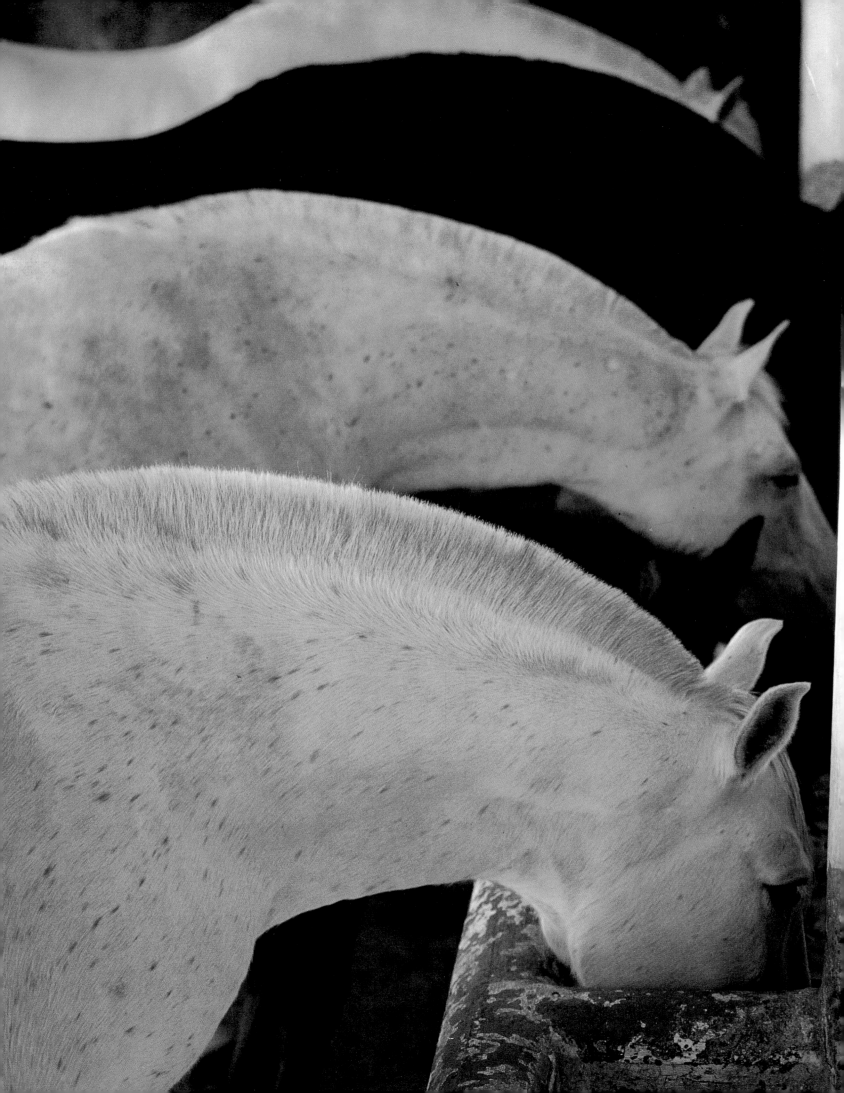

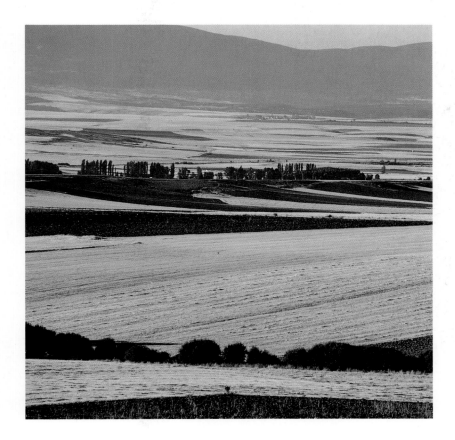

decorated with marble and masterpieces of the goldsmith's art. As a synthesis of all these styles, Seville's cathedral takes the breath away. Its imposing dimensions – 130 m (426 ft) long by 76 m (250 ft) wide – are overwhelming! It boasts a central nave and five aisles, sixty pillars, more than eighty arches reaching up to 59 m (193 ft) at their apex, decoration by Murillo (and many others), marble tombs, Baroque organs, solid-gold chalices and monstrances, doorways of jasper – a surpassing marvel at the heart of a city of marvels. How could one miss the ancient minaret crowned with its Giraldillo, the bronze statue symbolizing the faith, rising above the jumble of roofs (so low because some districts are below sea level)? And, seeing this architectural allegory which has survived the extremism and overbearing power of Christian Spain, how could it escape one that the symbol of this past splendour is Andalusian? Suddenly, all the pomp of Europe's past mingles with that of Seville. And one is certain that, like the Giraldillo which never faces the breeze head on, Seville will always know how to trim its sails to the wind of history.

*A*long the Guadalquivir, *on the road to Córdoba, the rich owners of vast agricultural holdings can sometimes be seen visiting their estates on horseback. The sun-drenched plain of the Campiña, around Ecija, is known as Spain's frying-pan.*

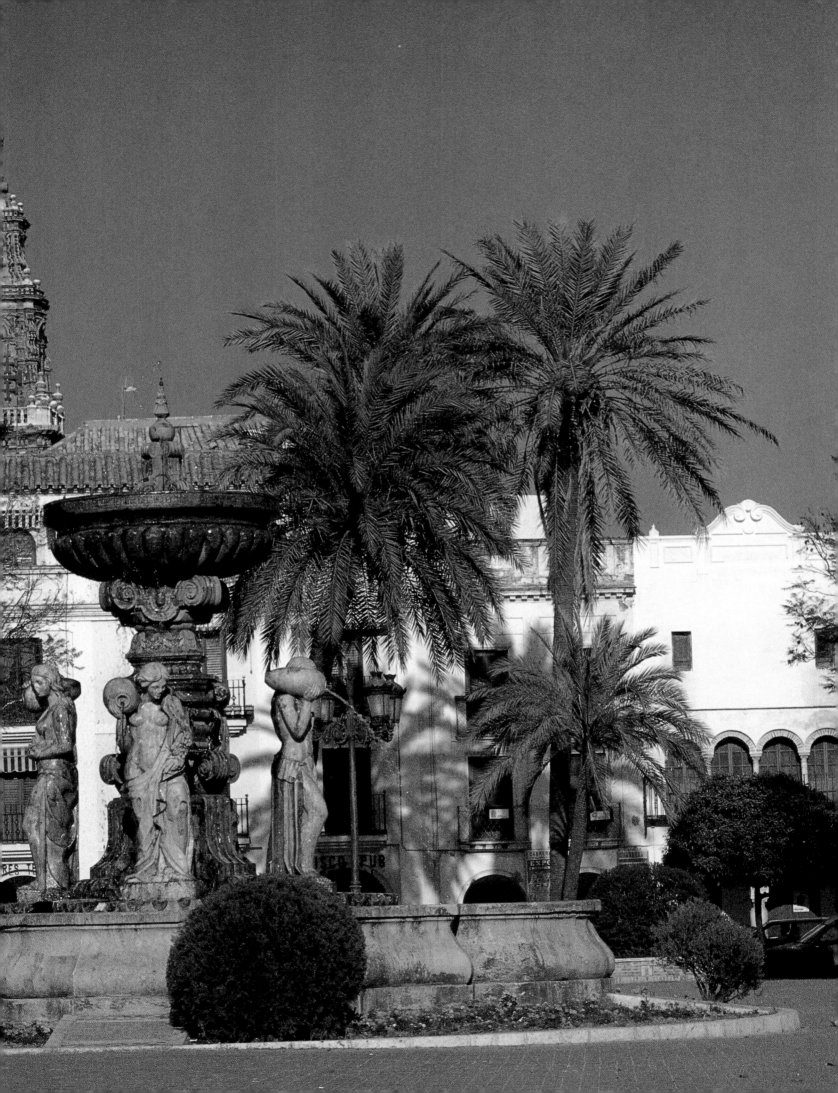

• Flamenco •

A provocative but liberating lament, heavy with irony, if not derision for the slings and arrows of outrageous fortune, flamenco rests on paradox and is nothing if not a way of life. The origin of the term is a matter of controversy. It is thought to derive from the arrogant attitude of the Flemish counsellors at the court of Charles V, or possibly from the haughty carriage of dancers imitating the stiffness of the pink flamingo. Although at every *feria* the streets are taken over by dancers swaying their hips in swirling, bright-coloured skirts, this kind of flamenco is anathema to purist devotees of *cante jondo*. Because of the subtlety of this "profound song", it is something of an elite form, though born of the musical genius of the most marginal and persecuted community in Spanish history: the gypsies. Originally from northern India, they reached the Iberian peninsula in 1440 and mingled with the Muslim and Jewish outcasts who had not yet fled the *Reconquista*. These nomadic beggars, craftsmen, and horse-dealers adopted Jewish liturgical psalms, guttural Arab songs, and Gregorian plain chant borrowed from the Mozarabs (Islamized Christians who had been permitted to retain their faith in the days of the caliphate). From these three musical traditions, and from later sufferings, was born this captivating cry of rebellion, the *cante jondo*. The man breaks into song to find release from his betrayal by a beautiful woman, or his anguished loneliness, or to express vibrant defiance against the unbearable constraints of life. In the *baile*, or dance, the woman responds with equal sincerity, accompanying her movements with finger-snapping and the stamping of feet. There is no written music, as the gypsy tradition is purely oral. The singer gives free expression to the soul's torment, and his emotional trance, or *duende*, is unique to each performance. Popular enthusiasm for this type of music dates from the nineteenth century, when one of the first and most famous *cafés cantantes* was opened by Silverio Franconetti in the Triana district. At the same time, guitar accompaniments became common, and *cuadros* (small groups) were formed. These consisted of a guitarist, a singer, and a dancer. Losing some of its spontaneity, flamenco became consequently and irrevocably a professional activity.

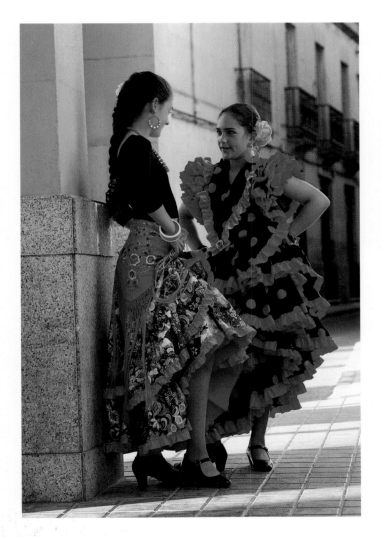

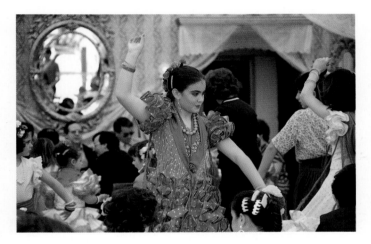

*A*n essential female accessory
during the April feria is the
traditional flamenco costume,
consisting of a shawl and a long,
weighted skirt with an elaborately
flounced hem.

The long alluvial valley
of the Guadalquivir
seems always to have protected the city
from the harshness of life.

CÓRDOBA

The provinces of Córdoba and Jaén manifest a quiet pride, a relaxed way of living from dawn to dusk beneath a pure sky, as if they wanted for nothing. The land, cherished for millennia, has made them extremely vulnerable to invading armies. Here and there, the undulating sea of olive groves laps up against the paddocks of some lordly *hacienda*, where bulls are carefully selected for combat. Where necessary, vines dispute the best slopes with the olive trees, to give Montilla one of the most famous of Spanish wines, aged in terracotta jars and unrivalled as an accompaniment to *pata negra*, the local mountain-cured ham. At a bend in the river, the stubborn Moorish fortress of Almodóvar del Río catches boldly at the almost feminine undulations of the horizon, dominating a village somnolent against its stony hillock. In the heart of the plain, cereals and cotton ripen in the silent monotony of the burning air, wrapping their silky cape about far-flung but substantial farmsteads.

Though they bring life, the waters of the Guadalquivir cannot satisfy all the needs of the 57,000 km² (22,000 square miles) of the Campiña. And the vast areas of arable land offer few prospects for the less fortunate. Drought aggravates unemployment among agricultural workers, most of whom work as casual labourers on the big estates. But in this Spanish

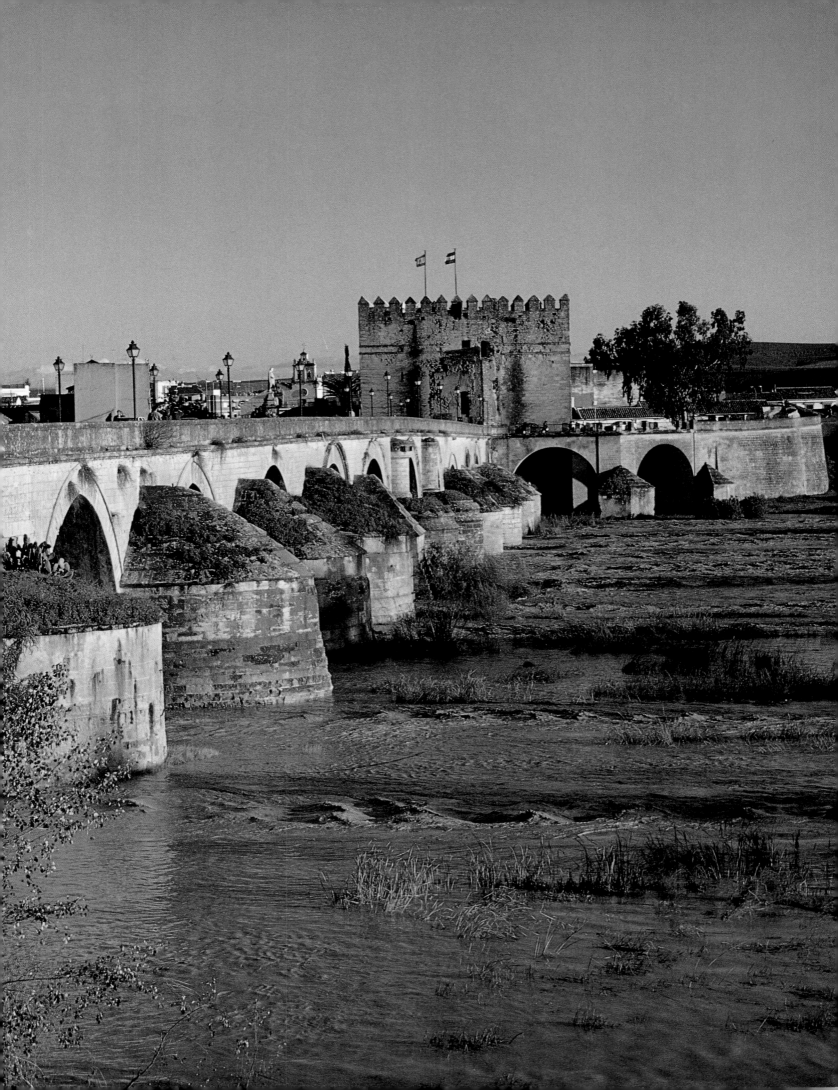

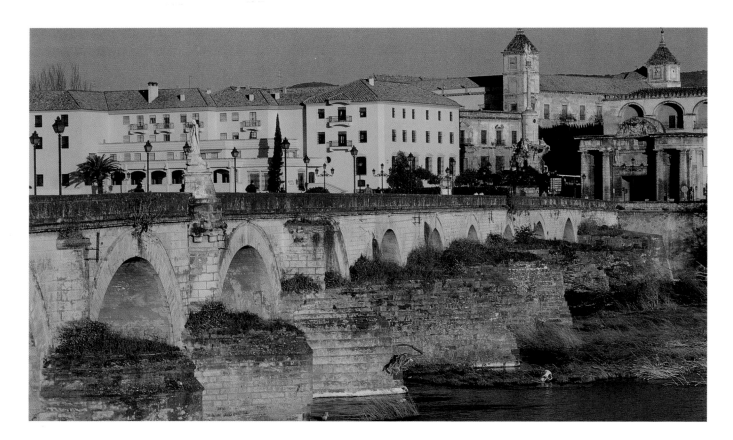

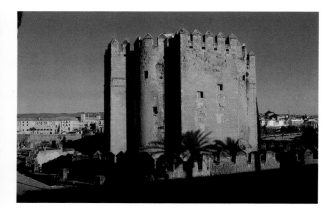

*T*he Roman bridge across the Guadalquivir, 240 m (785 ft) in length, connects the town with the Torre de La Calahorra. This old tower now houses a museum of three cultures: Jewish, Christian, and Muslim.

mezzogiorno, young people do not respond readily to the siren song of emigration, and life goes on without radical change.

In the summer holiday season, the area is traversed by processions of coaches from Castile, which stop in Córdoba before going on to Seville. Whether lacking time or interest, tourists tend to neglect the majestic austerity of the Sierra Morena, north of Córdoba, and the restful music of the streams of the Cazorla massif, east of Jaén. Only hardened ramblers, prepared to put in long hours of serious walking, seek out a beauty too pure to be glimpsed from the main road. The oak forests of the Morena (which means brown) form darker patches among the subtle greens of its eroded uplands, which abound in game. In the hollow of its valleys, white hermitages are the only signs of human presence for huntsmen in quest of stag or wild boar. Water penetrates every nook and cranny of the rocks of the Sierra de Cazorla, which conceals the source of the Guadalquivir, as well as otters and the nests of the bearded vulture (or lammergeier).

In these two provinces, we encounter a different Andalusia – different, or perhaps just closer to her roots; discreet, wearing her ageless brilliance without too much fuss; confident of having already proved herself, of having made her contribution to Spain, and indeed the rest of Europe. Córdoba was after all the birthplace of Seneca, one of the wisest of Roman philosophers. And it was in Córdoba that Averroës and Maimonides – one an Arab, the other a Jew; both physicians and philosophers – attempted to reconcile their faith with the logic of Aristotle. Above all, it was from Córdoba that Al Andalus, the Omayyad power that occupied three quarters of the peninsula, bequeathed to the medieval West the theories on which its later progress was based. On the orders of the caliph, the four hundred thousand books in the city's library, a formidable storehouse of knowledge, were translated from Greek, Egyptian, Hebrew, Sanskrit, and Persian. Such intellectuals and scientists as Europe could then muster were irresistibly drawn to this cultural beacon. It was Córdoba that disseminated philosophy, arabic

The Judería, Córdoba's old Jewish quarter, was the centre of a dynamic culture in the Middle Ages. Its winding, narrow lanes are now an ideal place to wander in search of the city's soul.

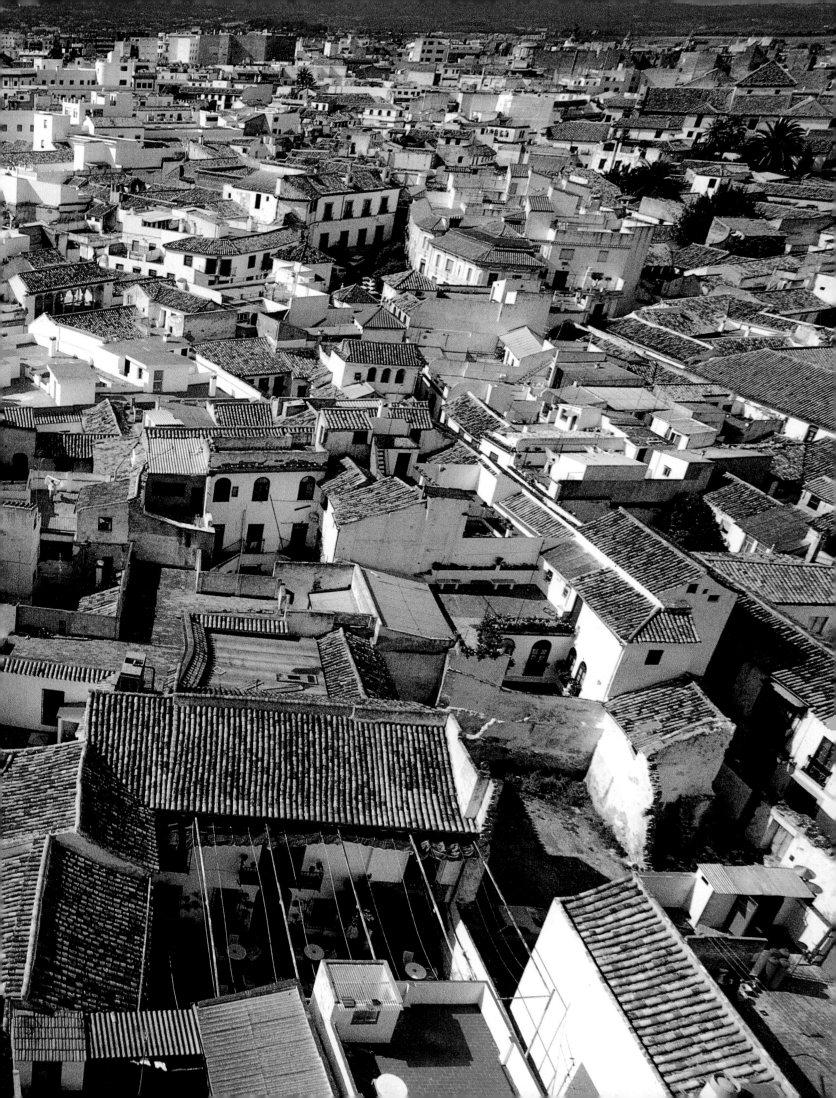

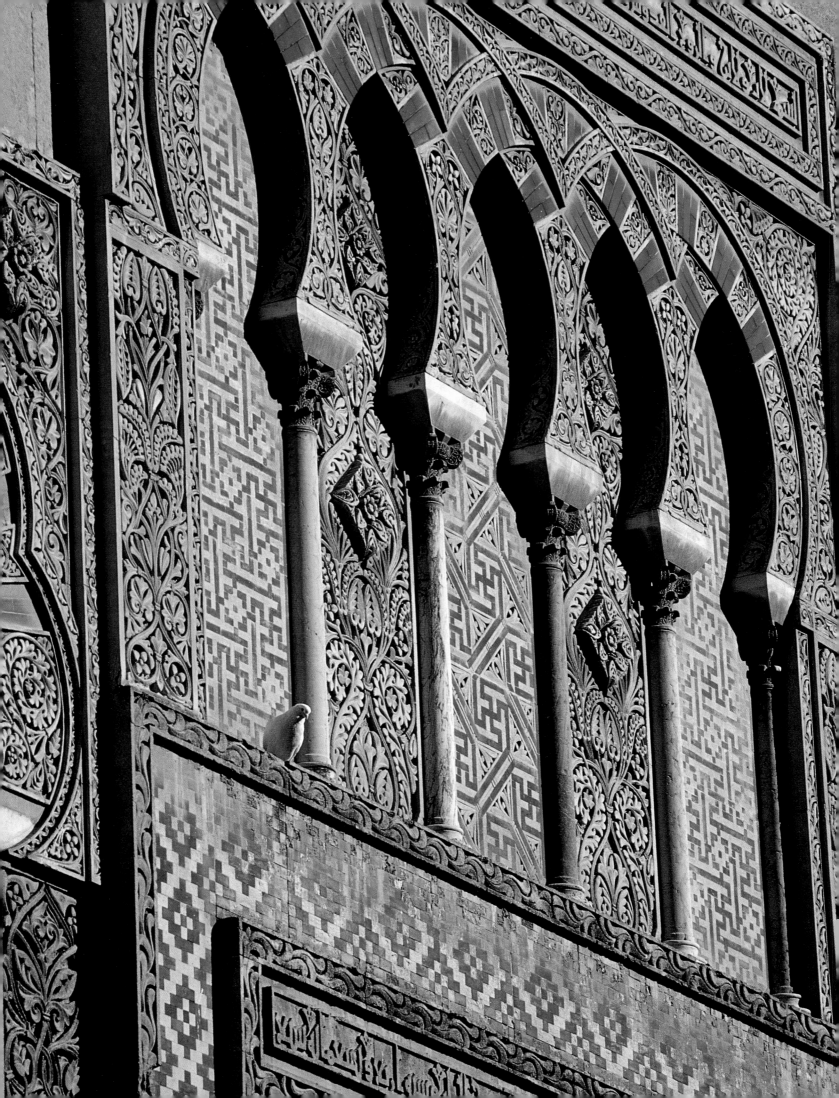

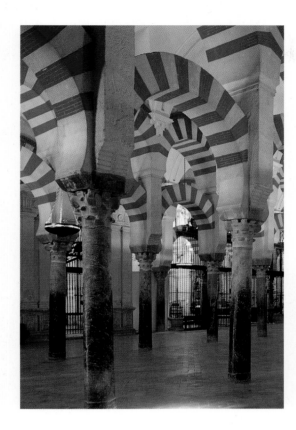

Córdoba's mosque, with its mihrab and assembly area supported by 850 marble and jasper columns, is a masterpiece of Islamic architecture. Begun in 785, the building was completed at the end of the tenth century.

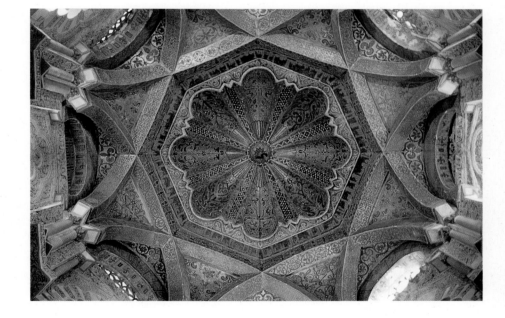

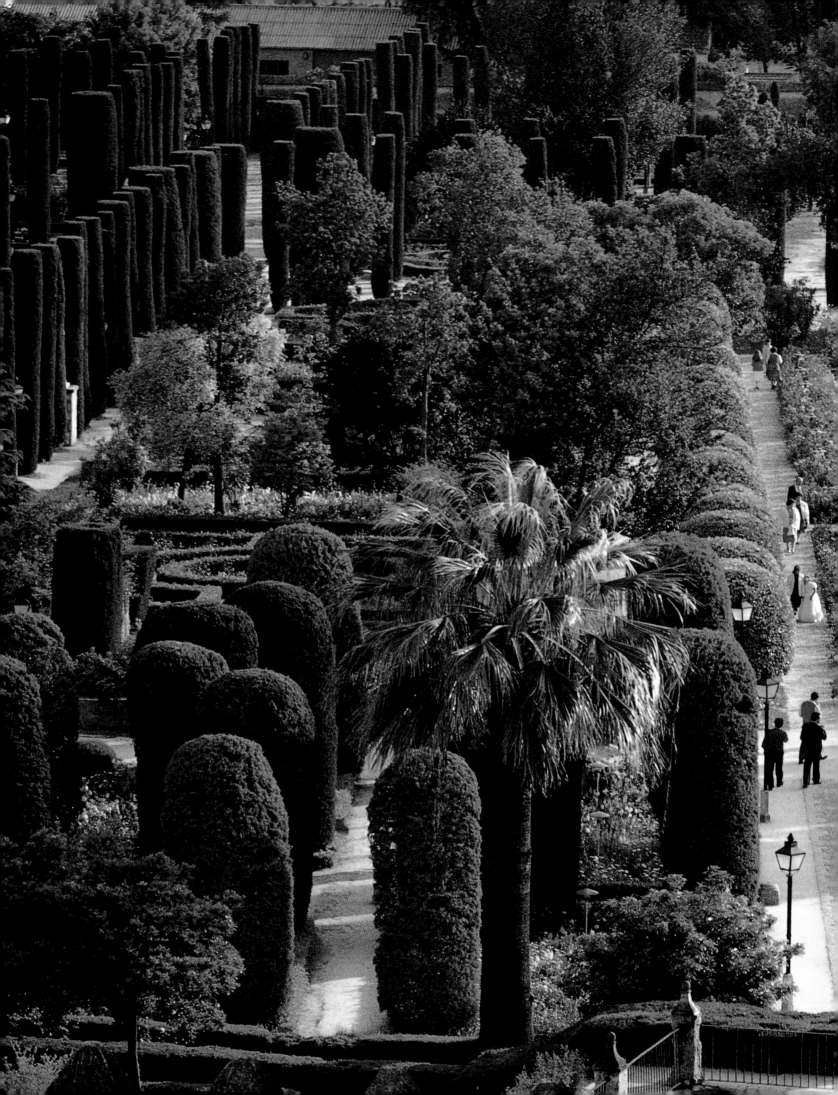

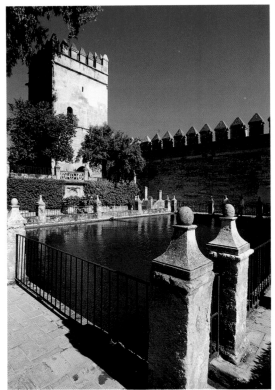

*Córdoba's Alcázar, with its
splendid patio, was built in the
mudéjar style by the Catholic kings
in 1328. Until the eighteenth
century, it housed the tribunal of the
Inquisition. The walls of the chapel
in which the inquisitors deliberated
are decorated with Roman mosaics.*

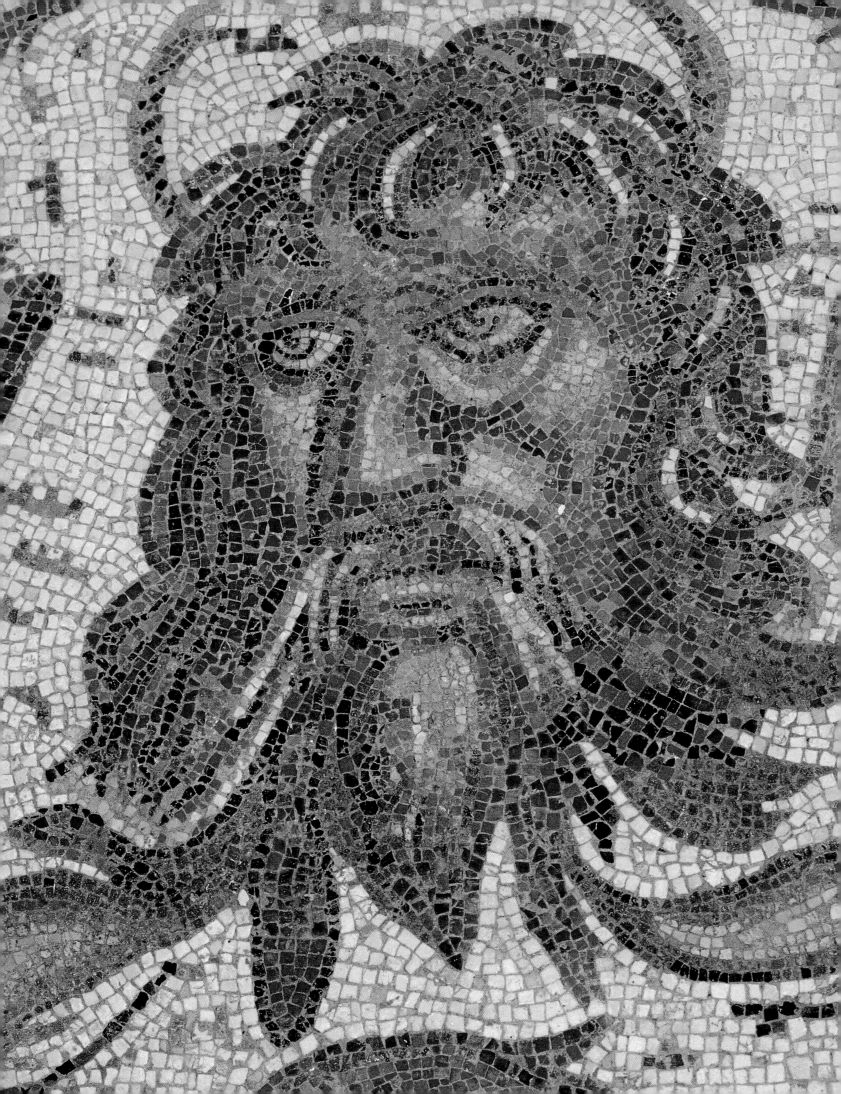

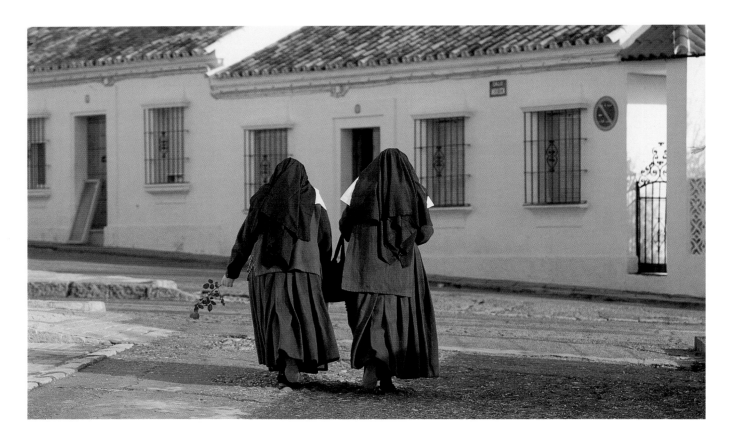

Nestling in the foothills of the Sierra Morena, Las Ermitas (the hermitages of Córdoba) offer tranquillity and wonderful views of the mountains and city.

numerals, and the fundamentals of algebra, astronomy, and medicine. During the reigns of Abd Al-Rahman III (912–961) and Al Hakam II (961–976) the city's influence came to rival that of Baghdad. The Moors' insatiable curiosity and interest in the human sciences gave rise to many legends. It is said that, in the latter years of the caliphate, the warlike Al Mansour (976–1002) would never join battle without his squad of poets! Prosperity went hand in hand with a sympathetic appreciation of the differences of others, and the caliphs made clever use of skills, from whatever source. They did not force the Christians to convert. Jews were attracted by the Talmudic schools. Al-Rahman III chose a Jewish minister of finance, and other rulers had Christian viziers. So Córdoba became the Andalusian exemplar of co-operation between the three monotheistic religions. And if, from fear of lowering the tone, we omit from this long record of intellectual achievement the exploits of the bullfighter Manolete, the average Cordovan will not be offended. He knows that in the bullring, as elsewhere, his city has nothing to prove.

What then can we derive from the present, in this city of honey-coloured stone, girded by its river, aground on its only rampart, the severe perimeter of the Grand Mosque? At the risk of sounding corny, we can begin, like the three hundred thousand Cordovans, by adopting its gentle way of life – rather middle-class, it is true, on the evidence of the Plaza de la Tendillas, where stands El Corte Inglés, the town's main department store. Or if it is modernity you are looking for, try visiting the northern districts, so highly praised by devotees of modern architecture, admirably equipped to welcome banks, high-speed trains, and the businessmen who use them. Or again, if you want to improve your mind, to wander down to the ancient Roman bridge. This leads to the Torre de la Calahorra, a former guard tower which houses the Museo de las Tres Culturas. A pedagogical celebration of the interpenetration of three cultures – Jewish, Christian, and Muslim – it was the brainchild of the controversial French philosopher Roger Garaudy. But the sober temperament of the Cordovan has little time for intellectual cleverness.

Abundantly watered by mountain streams and the mighty Guadalquivir, the verdant landscape of the Andújar region comes as a surprise in the south of Spain.
Following pages:
Standing out boldly against the horizon, the seventh-century Moorish castle of Almodóvar del Río watches over the white village below.

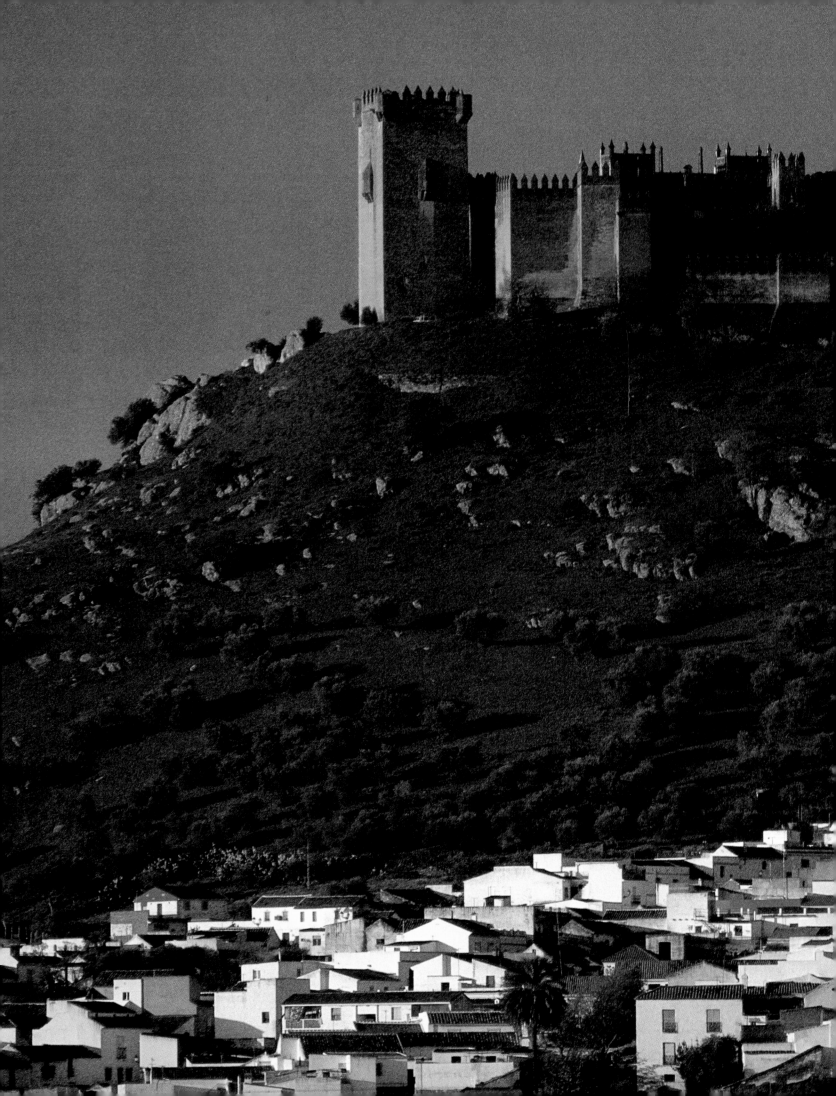

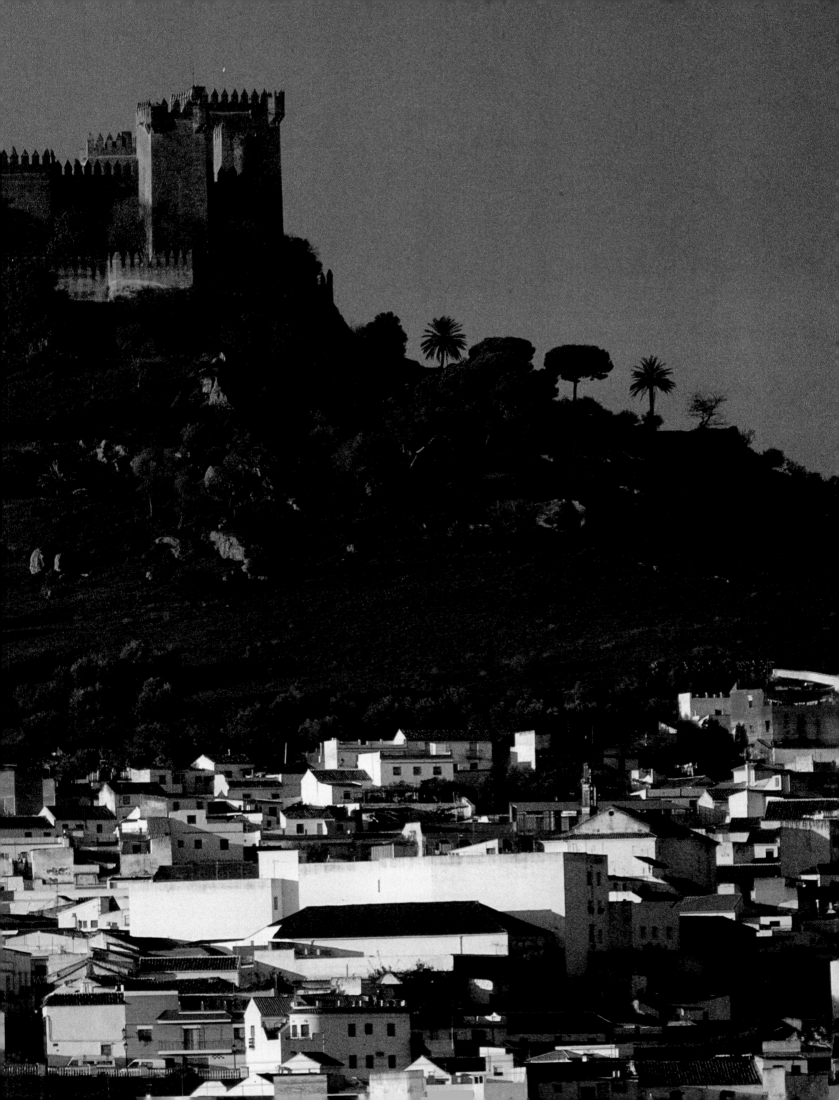

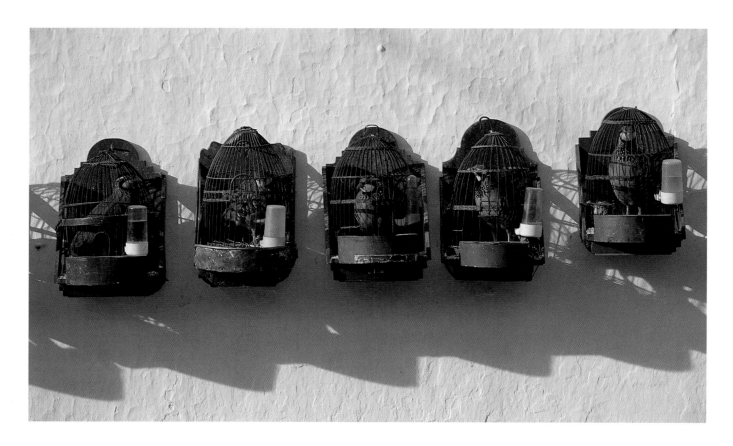

*P*art of the traditional rural
lifestyle, hunting is a local passion.
These caged partridges are used as
decoys to lure others to within range
of the huntsmen's guns.

He accepts it as just one more proof of superiority. On the other hand, he gives very serious attention to the way he simmers his *rabo de toro*, an oxtail and vegetable stew. He heaps praise on the town's flamenco art festival, and every spring shows great enthusiasm in preparing for the best-kept-patio competition. There is no question of his abandoning this tradition: the patios of Córdoba must remain the most beautiful in Andalusia. In Córdoba, not content with their place in secret gardens hidden away behind wrought-iron grilles, the flowers invade the street, spilling chaotically yet artistically from dozens of pots attached to every wall. And the alleyways of the Judería, the ancient Jewish quarter organized around its synagogue and the Plaza Maimónides, present a visual harmony from which even the bustle of tourism cannot detract. It is a Cordovan principle never to sacrifice memory to necessity. Back in 1523, the bishop of Córdoba, urged to continue the work of "christianization" of the mosque, which had been stopped by Isabella the Catholic, discovered this to his cost. The city councillors threatened with

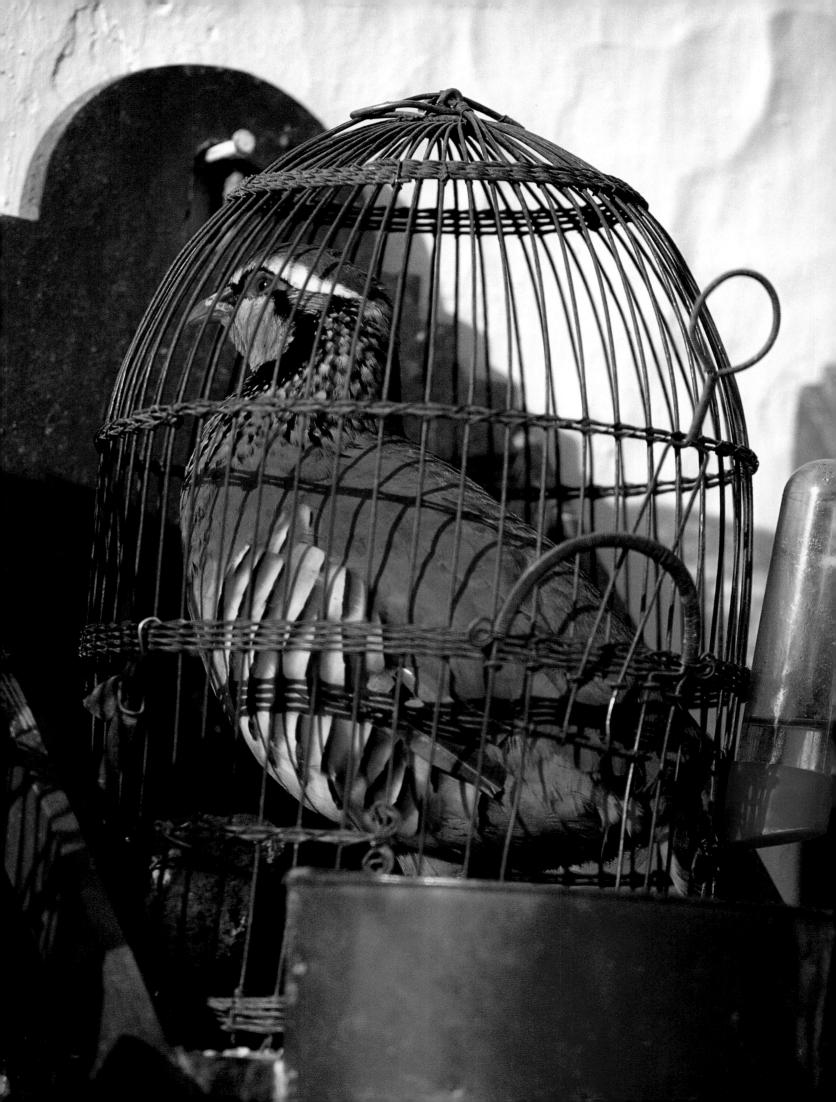

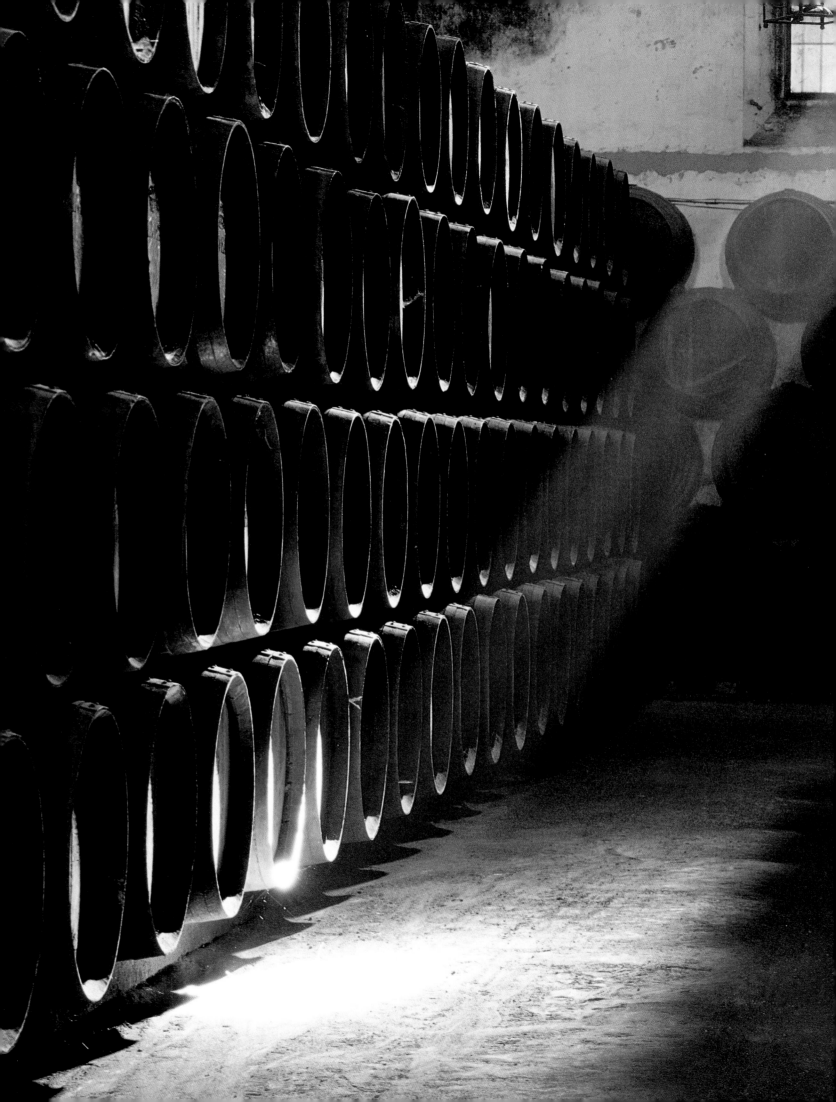

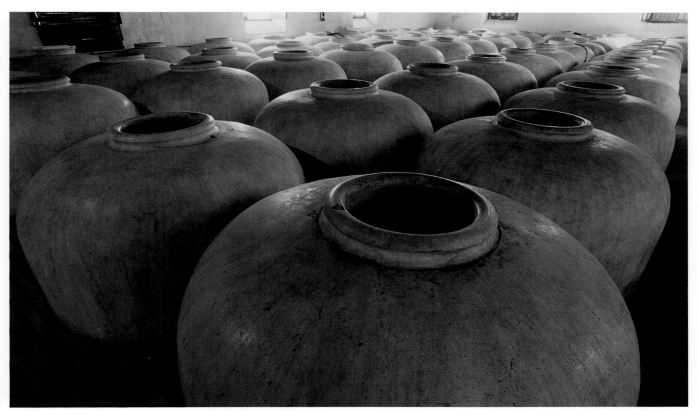

death anyone who adulterated this imperishable jewel! Although Charles V finally authorized the sacrilege condemned by his grandmother, he subsequently regretted his decision and vented his indignation on the architects. Even today, on seeing the mosque's 850 columns and the cupola of its mihrab, stunned visitors condemn the miserable attempt to erect a cathedral within its precincts.

As well as a spiritual dimension, Córdoba has a sense of righteousness. This ethos also gives the town its political bearings. Although not particularly working class, it is traditionally to the left of left. Red Córdoba's socialist solidarity is most apparent on the eastern side of the Plaza de la Corredera market, where artisans working in leather and filigree silver ply their trade. "He who sets store by the judgement of the people of his time is born for small things", said Seneca, one of its most enlightened native sons. No doubt that in this respect, Córdoba has nothing to learn from anyone.

Wines from the vineyards of Montilla Moriles are aged in jars of terracotta. Sweet and aromatic, they are often drunk with dessert. Drier types go well with pork products. Following pages: Between Seville and Córdoba, the plain of the Guadalquivir stretches away into the distance. In this area, the landed gentry grow cereal crop and raise bulls.

Between two princesses,

Córdoba and Granada,

Jaén is too inclined to accept the role of lady-in-waiting.

JAÉN

Jaén's Renaissance-style cathedral was begun in 1492 but not completed until 1802. The Baroque additions do not detract from its essentially classical appearance.

Jaén has a bit of an inferiority complex. Yet the town rises from an ocean of olive trees, nestling in a circle of hills dominated by a Moorish lookout post, the Castillo de Santa Catalina. In former times, this proud bastion dampened the warlike ardour of Catholic troops from Castile as they marched towards Andalusia. It is an ideal observatory for surveying a province girded by mountains and extensive forests. The Romans, who knew the town as Aurinx, dug here for lead with a high silver content, and it was the stronghold of the Zanata berbers until they were conquered by Ferdinand III of Castile in 1246. It has two other significant landmarks, catering respectively for soul and body. The cathedral, bristling with sculptures, is one of the masterpieces of Spanish Renaissance architecture. It houses a tabernacle containing the cloth with which St Veronica is said to have wiped Christ's face. The nearby Palace of the Counts of Villardompardo is a cultural monument of a different kind, but no less interesting. It conceals an Arab bathing establishment dating from the eleventh century, the largest in Andalusia. A labyrinthine *hammam* in an excellent state of preservation, it shows that the Muslim conquerors from North Africa were very particular about their personal hygiene.

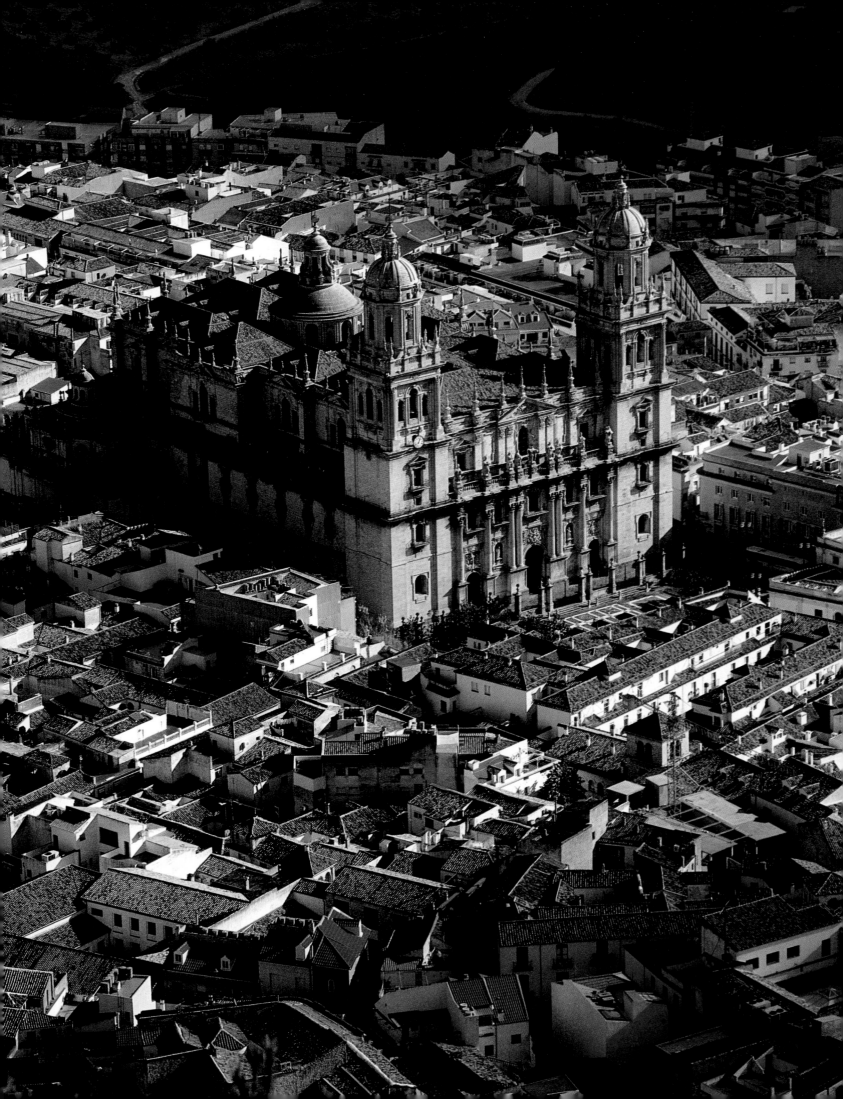

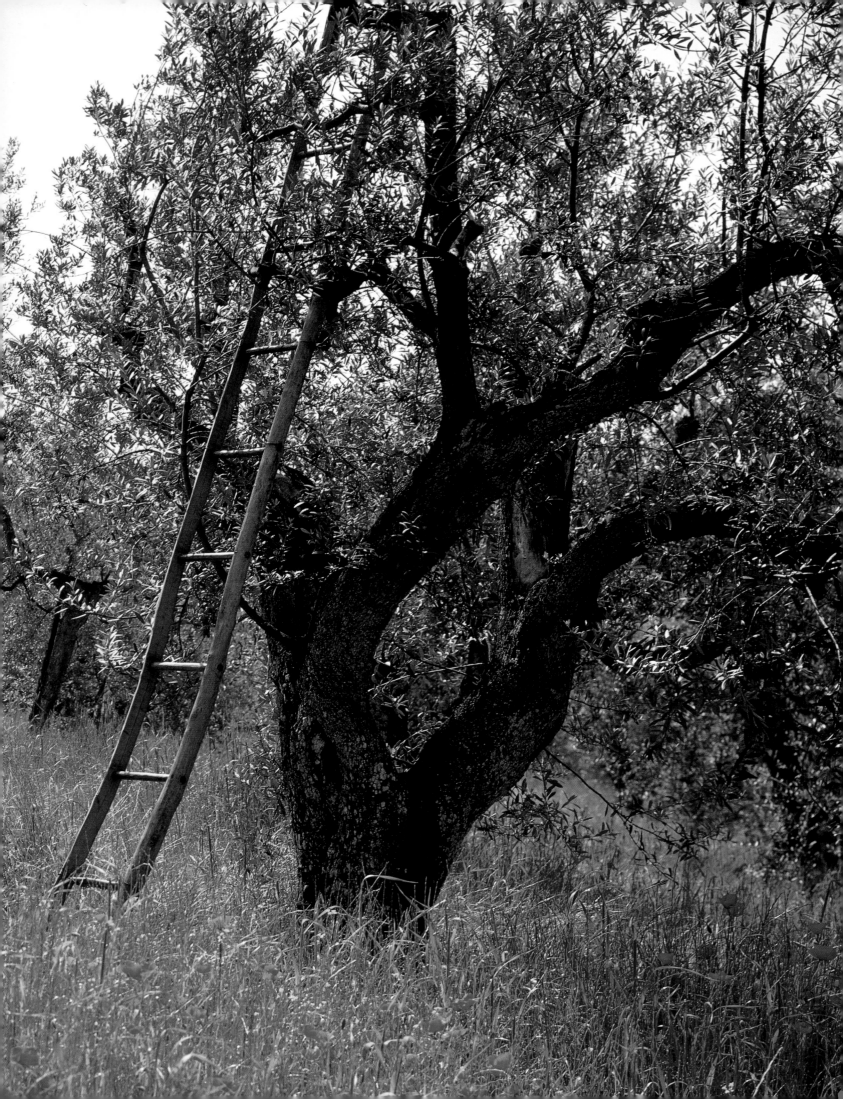

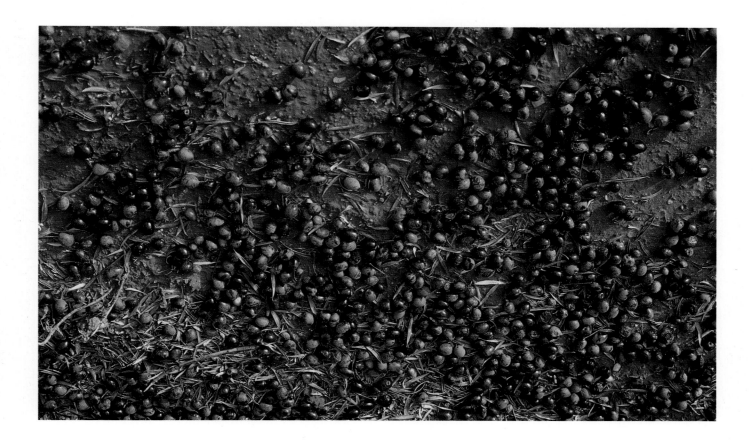

Olives are harvested in November and December.
The olive groves in the region of Jaén yield some 200,000 tonnes of oil a year.

• Olives •

The ochre soils of Jaén province, planted with over 150 million olive trees, are scored with endless lines of arborescent green. The knotty-trunked trees, 90% of the Picual variety, are the main resource of this gently rolling region, creating one of Spain's most austere landscapes. Seasonal workers descend on the province in December to harvest more than 500,000 tonnes of olives on the great family-owned estates, or *latifundios*, which remain the foundation of the Andalusian agrarian economy. From these giant plantations are derived over 200 million tonnes of oil. The quality may vary, but nowadays the oil is tested and certified with a *Denominación de Origen Controlada*. The first cold pressing has the best flavour and is richest in the fruit's natural vitamins. In classical times, the olive tree was the symbol of peace and fertility.

"Weep now, like a woman,
for this kingdom you failed to defend like a man!"

GRANADA
and the Sierra Nevada

With these scornful words the mother of King Boabdil reacted to her son's sorrow one cruelly beautiful morning in January 1492.

The last sultan of the Nasrid dynasty had just turned his back on Granada, giving free vent to his grief. He rode on through the narrow valleys of the Sierra, heading for the sea and, across the straits, for Africa, his place of exile. Meanwhile, Isabel of Castile and Ferdinand of Aragon entered the city unopposed. Boabdil's tears marked the end of eight centuries of Muslim presence in Spain, whose destiny was now entirely Christian. As the sun rose that morning, its first rays lit up the most potent symbol of Islamic civilization in Andalusia: the blood-red hill of the Alhambra, its palace and gardens bathed in the heady perfume of a lost paradise, in an age-old indifference to the vicissitudes of history. For almost two hundred and fifty years, the Nasrid rulers had upheld the two grandiose illusions of peace and luxury, in exchange for their formal submission to the Catholic kings. When Córdoba and Jaén fell to the Christians, in 1246, Muhammad Ibn Al-Ahmar, the first of the line, accepted vassal status. Benefiting from the influx of refugees from other conquered towns, buoyed up by their commercial dynamism, he was

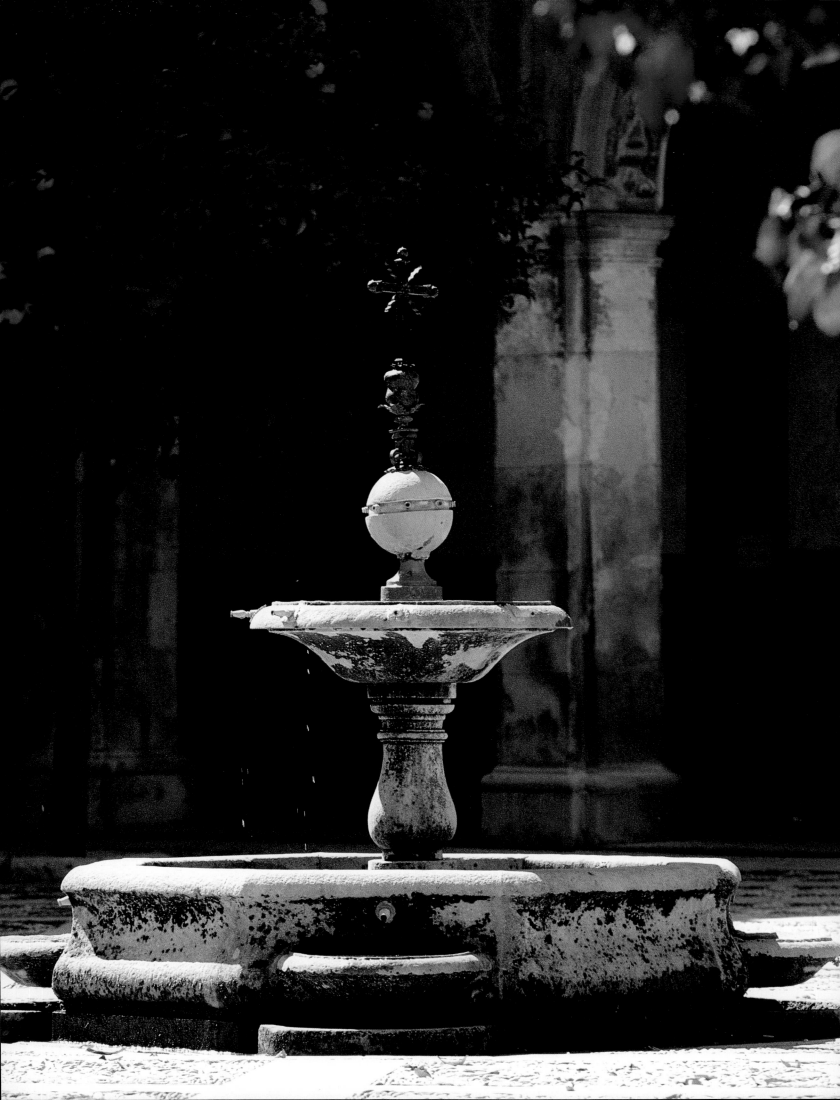

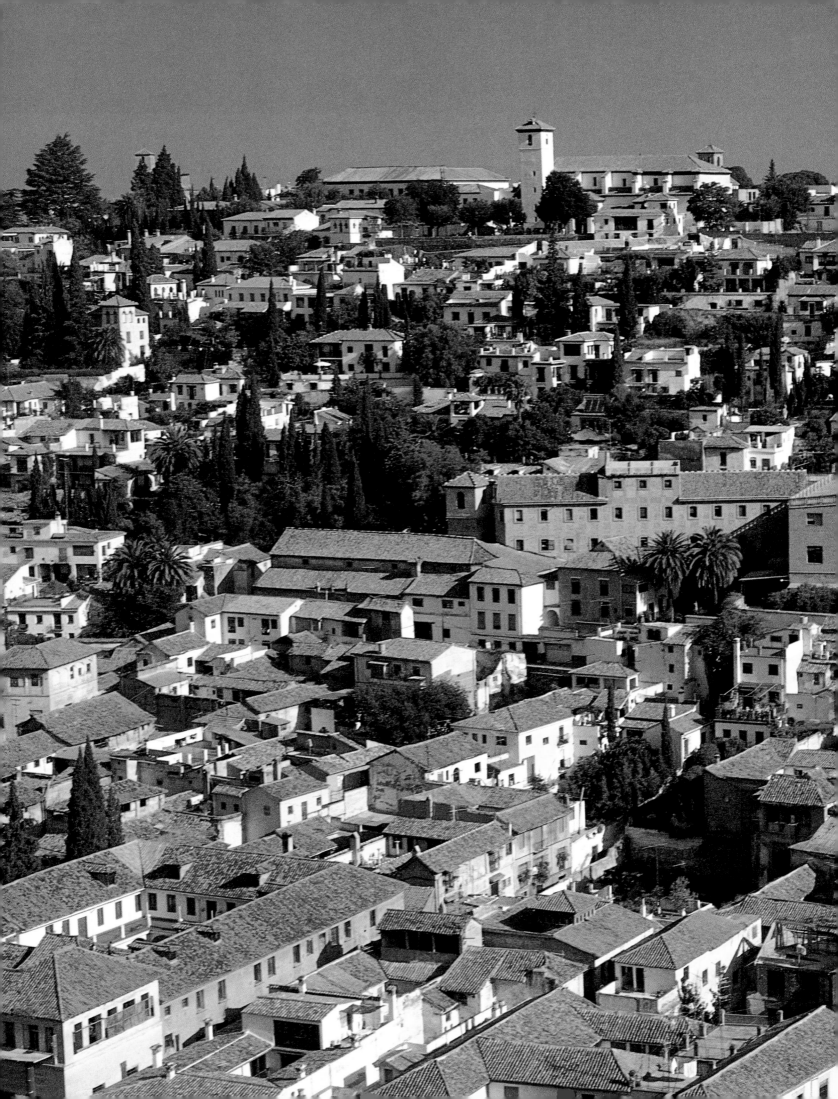

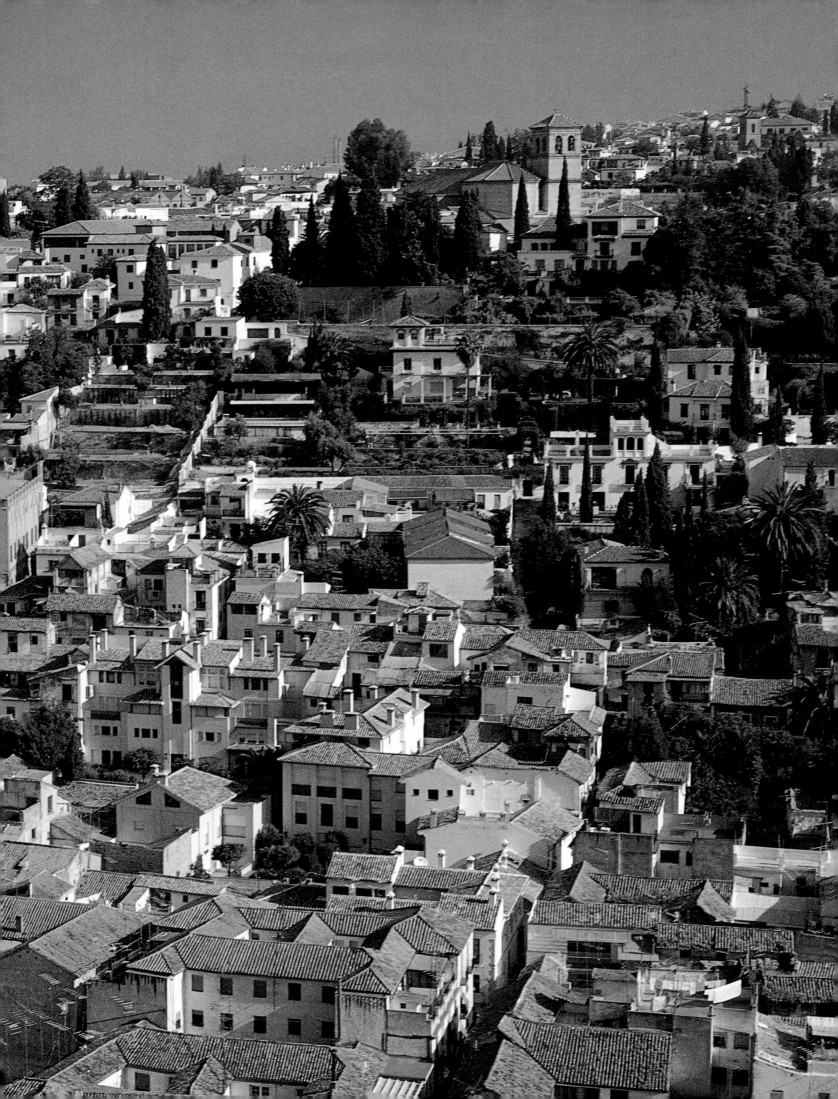

Granada's white-and-ochre streets wend their way around three hills, prefiguring the nearby summits of the Sierra Nevada. The Albaicín hill stands opposite the Alhambra and, when evening comes, its steep pathways draw both tourists and locals to watch the sun go down behind the former royal palace.
Following pages:
The impressive seventeenth-century organ cases of Granada's cathedral are in keeping with the building as a whole: 116 m (380 ft) long, 67 m (220 ft) wide, and with a dome 48 m (157 ft) high.

able to preserve his 30,000-km^2 (11,580-square mile) stronghold with its 400,000 inhabitants. There he built a kingdom, whose ebbing bursts of vitality were also the most productive of beauty.

The site he chose for his palace was exceptional: perched on a rocky escarpment overlooking the town, the plain of the Vega and the Rio Genil, lulled by the cheerful bubbling of the Darro cascading down its flanks, crowned by the snowy diadem of the Sierra Nevada. The rest is explained by the flickering flame of a culture under siege, given up to nonchalant fatalism. Surely, no royal residence has ever come so close to the sublime as the Alhambra and the gardens of the Generalife. The sensuality of the pink-ochre stone, wooed continuously by the reflected light of the ornamental pools, softened in places by caressing shadows, yields itself without shame or formality to the embrace of the mountains, the intense blue of the sky, the burning ardour of the ever-obliging sun. The marble paving slabs forego their own brilliance to enhance the subtle arrangement of the columns and fountains they

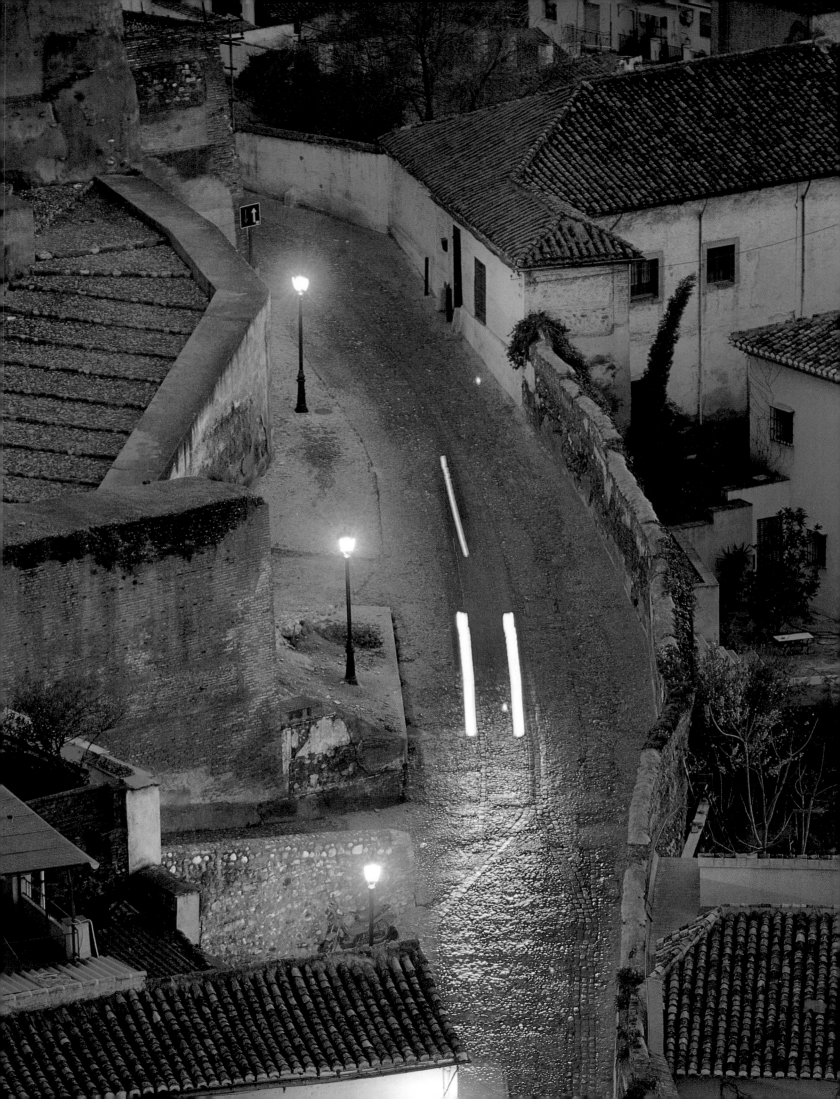

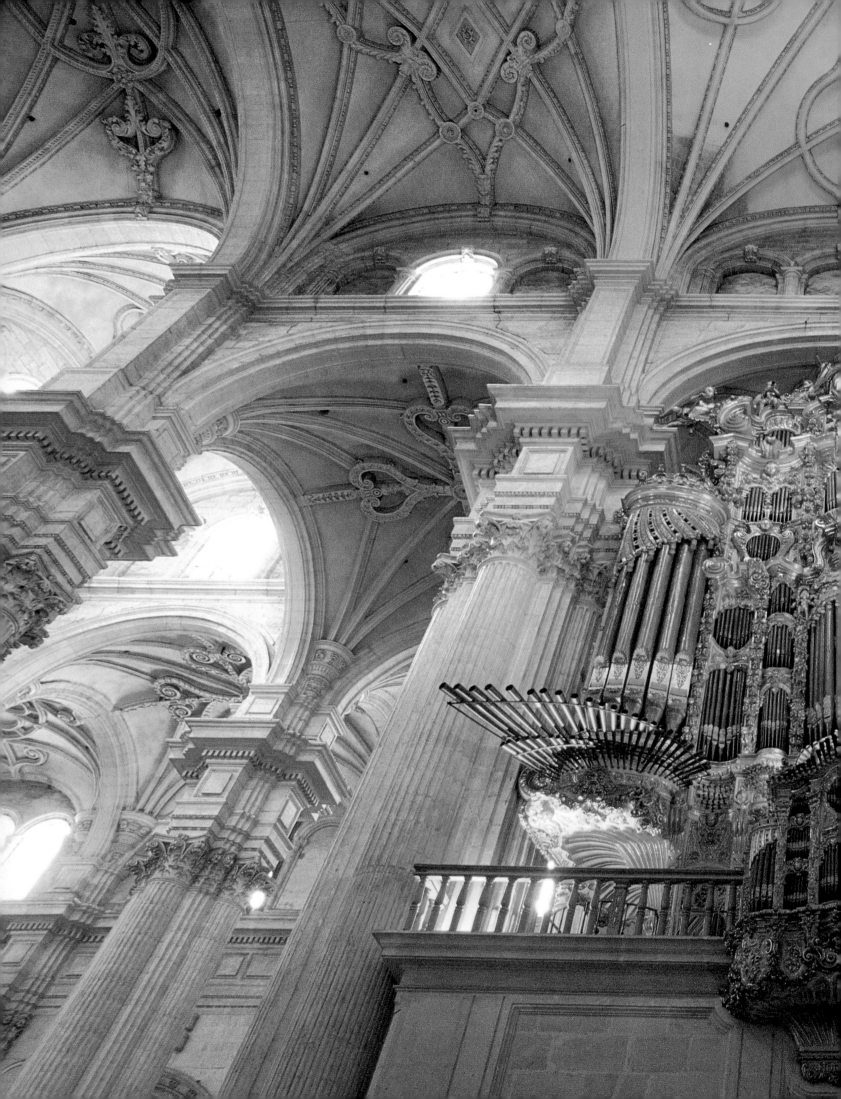

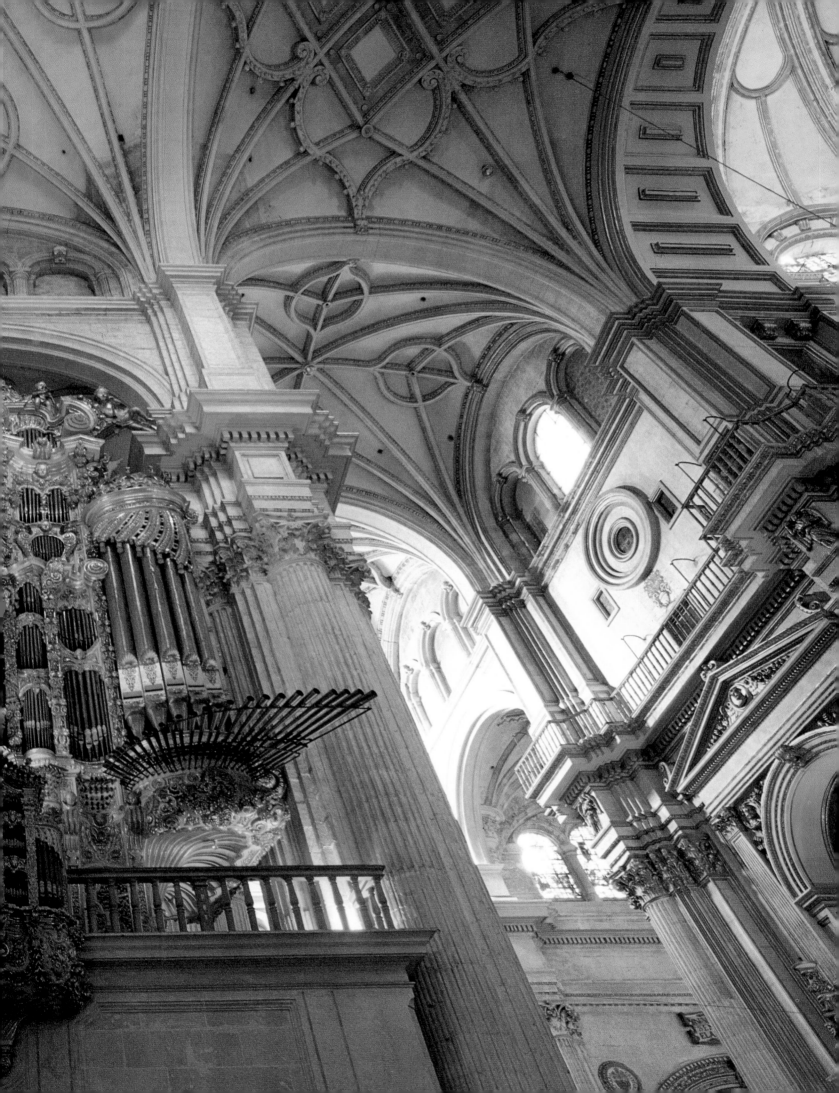

The interior of the Cartuja, the Carthusian monastery in the north of Granada, is one of the masterpieces of sixteenth- and seventeenth-century Baroque ornamentation. It has frescos by Juan Sánchez Cotán, and its walls are embellished with elaborate stucco work.

uphold. Encrusted with *azulejos* and stucco work, the walls bear witness to the perpetual quest for spiritual well-being we recognize in the Koranic faith. From the Court of the Lions to the Court of the Myrtles, the decadent civilization of the Nasrids, embodied in this perfect architectural parable of earthly happiness, communicates an emotional turmoil which acts like a spell.

In the gardens of the Generalife, the emirs' country residence, the heart is overwhelmed by a surging joy which only such a harmony of relationship between man and nature can inspire. Water, source of life for Muslims, springs forth on every side. Tiny, nourishing jets filter the light to produce an illusory rainbow, then create arabesques as they fall in myriad shining droplets on the barely restrained vegetation. Fostered by this prodigal dew, the fragrance of magnolia, cypress, rose, and eucalyptus envelops benches and low walls, infiltrating the very entrails of the palace. For here there is no schizophrenic distinction between interior and exterior, no retreat into a sterile cloister. Life circulates everywhere, conveyed in the veins of plants vibrant with sap and decked out in every shade of green, stirred by the music of water bubbling from fountains, or the discordant melody of bird song. The garden is not an

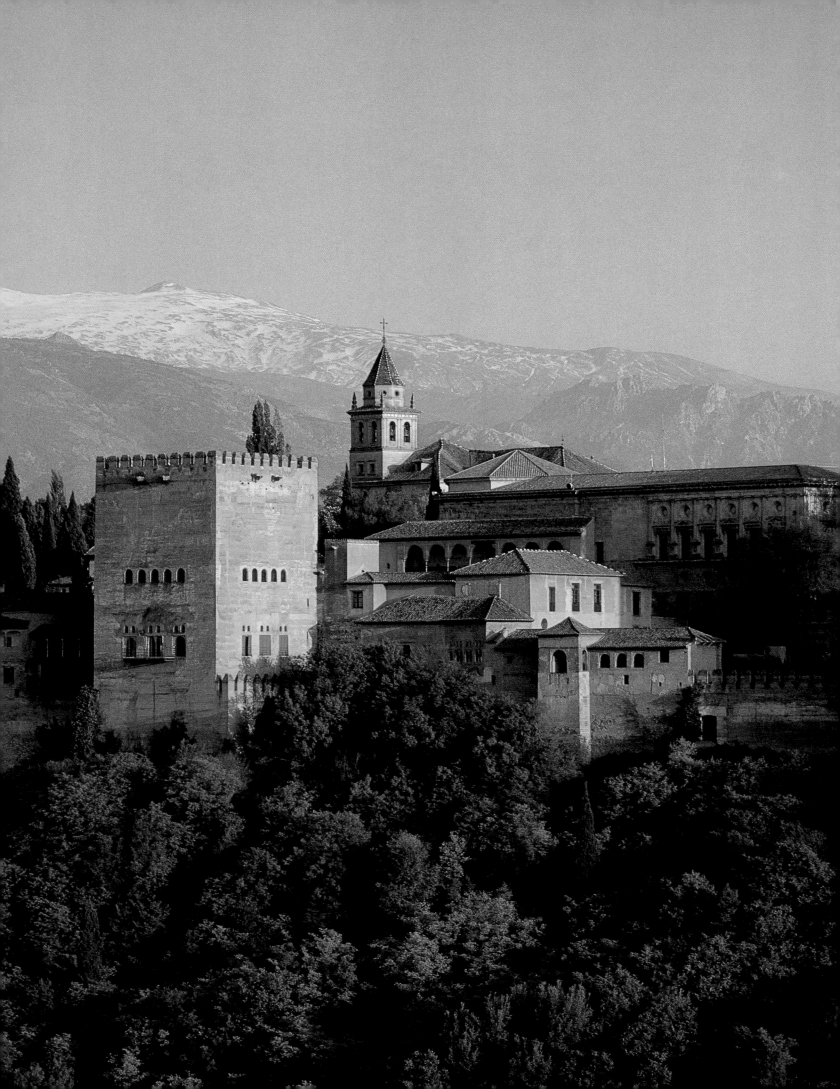

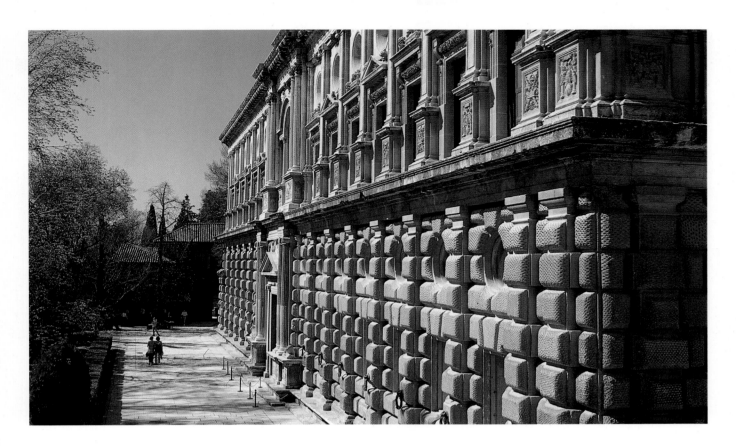

adjunct to the house, but an incarnation of the well-being it procures, an earthly means of initiation to the absolute, in which human beings also have their place.

Was it because he felt he was upsetting the spirituality of this environment that Charles V never lived in the Italianate palace he built, in 1526, at the heart of this Nasrid Eden? Is it because of the magnetic attraction of the setting that artists and thinkers have chosen to settle on the Albaicín, the hill opposite, from where they can keep it in view? Or is their decision rather an act of homage to the Moriscos, Muslims converted by force, then massacred on the Albaicín where they had taken refuge? Maybe it is the memory of all the blood shed after the Reconquest, the slaughter of gypsies and Marranos – Jews who underwent baptism but remained loyal to Judaism – and the expulsion of thousands of Jewish families on the orders of militant churchmen, that keeps Granada's eyes riveted on the Alhambra. Every evening, when the biting breath of mountain air refreshes the white façades and the

As the sun rises on the Alhambra, the stones of the Nasrid-dynasty palace blush red against the pure white backdrop of the Sierra Nevada.
In 1526, Charles V demolished some of the existing buildings to build a residence of his own.

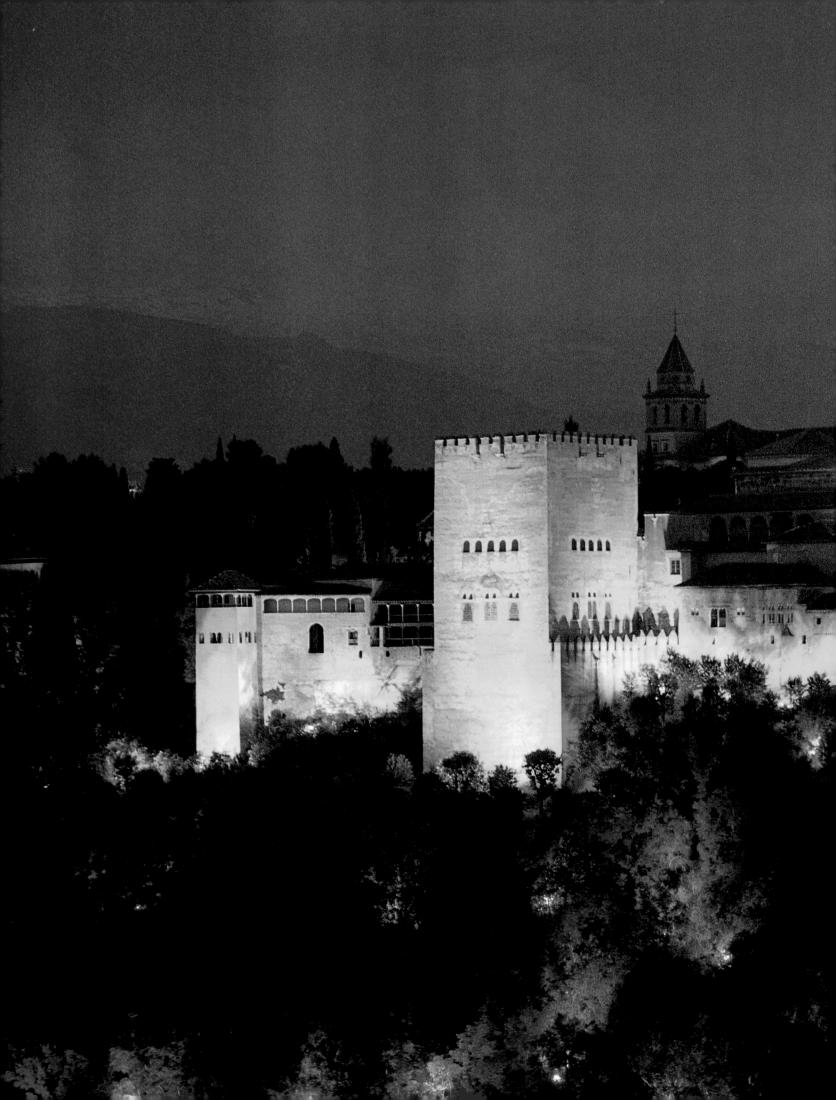

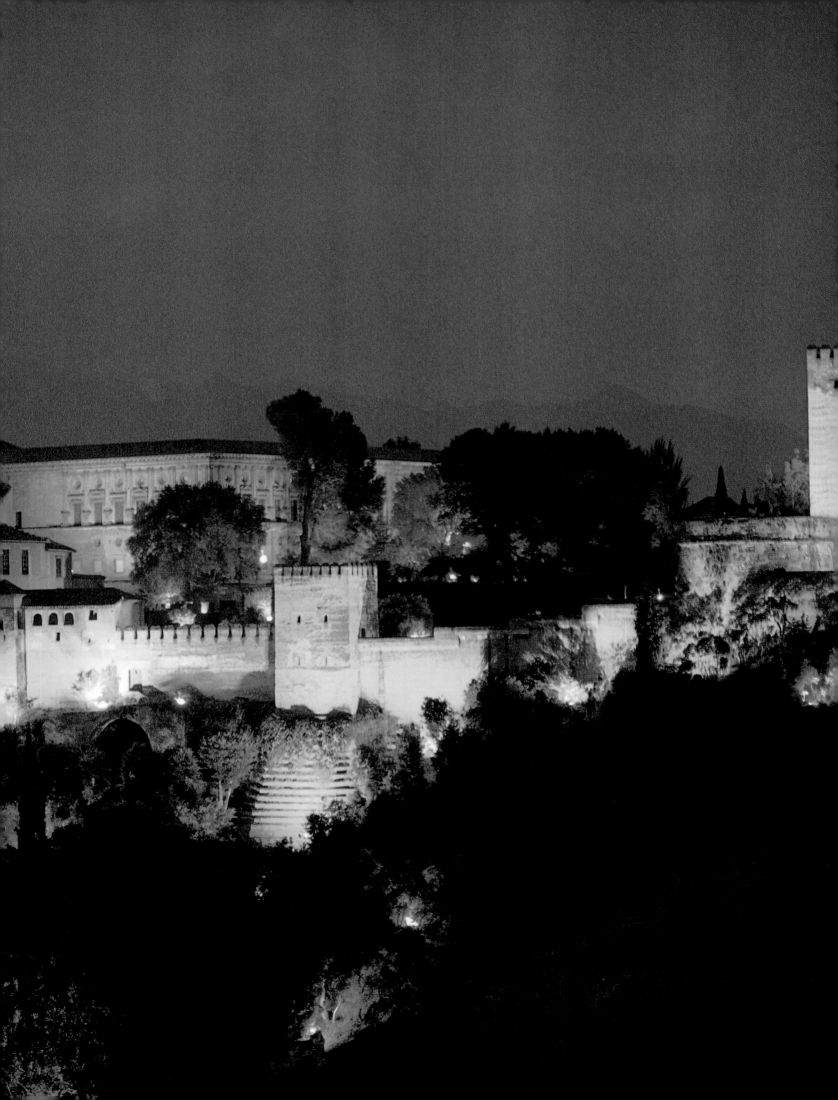

*T*he sophisticated stucco work and
azulejos *of the walls surrounding
the Court of the Myrtles are typical
of an architecture governed by
religious precepts. The verses of the
Koran are here reproduced in stone.*

disjointed paving stones of the Albaicín's alleyways, a familiar ritual is renewed. Grandmothers in black break off their conversations around the fountain, and even the endearments of young lovers are hushed, as the setting sun performs the final, Technicolor act of the daily spectacle. A dusky curtain descends on the embattled towers of the Moorish palace, breathing into the sky a vaporous mandarin-orange dust.

This is the way of things: Granada respects its symbols, but without the verve and festive frivolity of its Andalusian sisters. And although its universities account for one sixth of a population of 300,000, it has a reputation for being "down to earth", preferring simple pleasures to the exhausting task of being a cultural melting pot – despite the fact that a recent resurgence of interest in Islam has led to the teaching of more Arabic courses, and enthusiastic exchanges with Marrakesh and Taitouan. So the locals feast on ice creams along the Gran Vía de Colón and, on the stroke of six o'clock, congregate in the shade of Plaza Bib-Rambla to consume pyramids of *churros* dunked in hot chocolate. Similarly, they

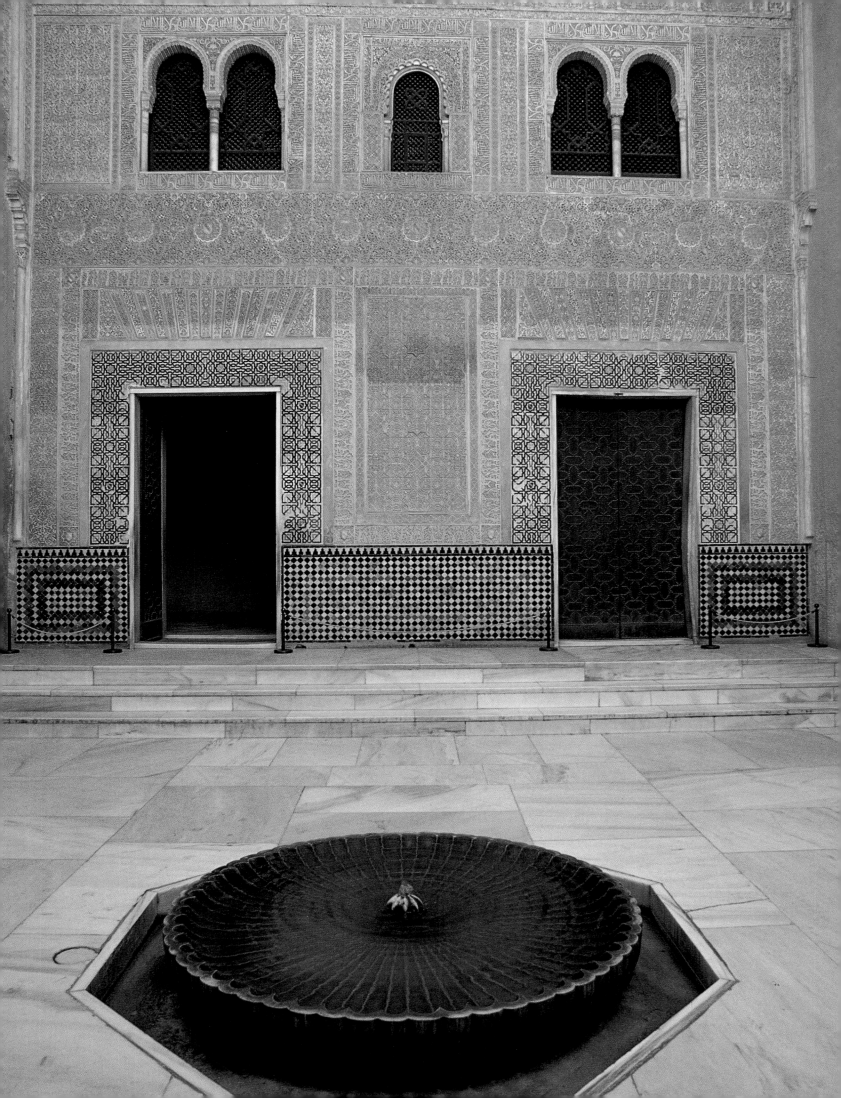

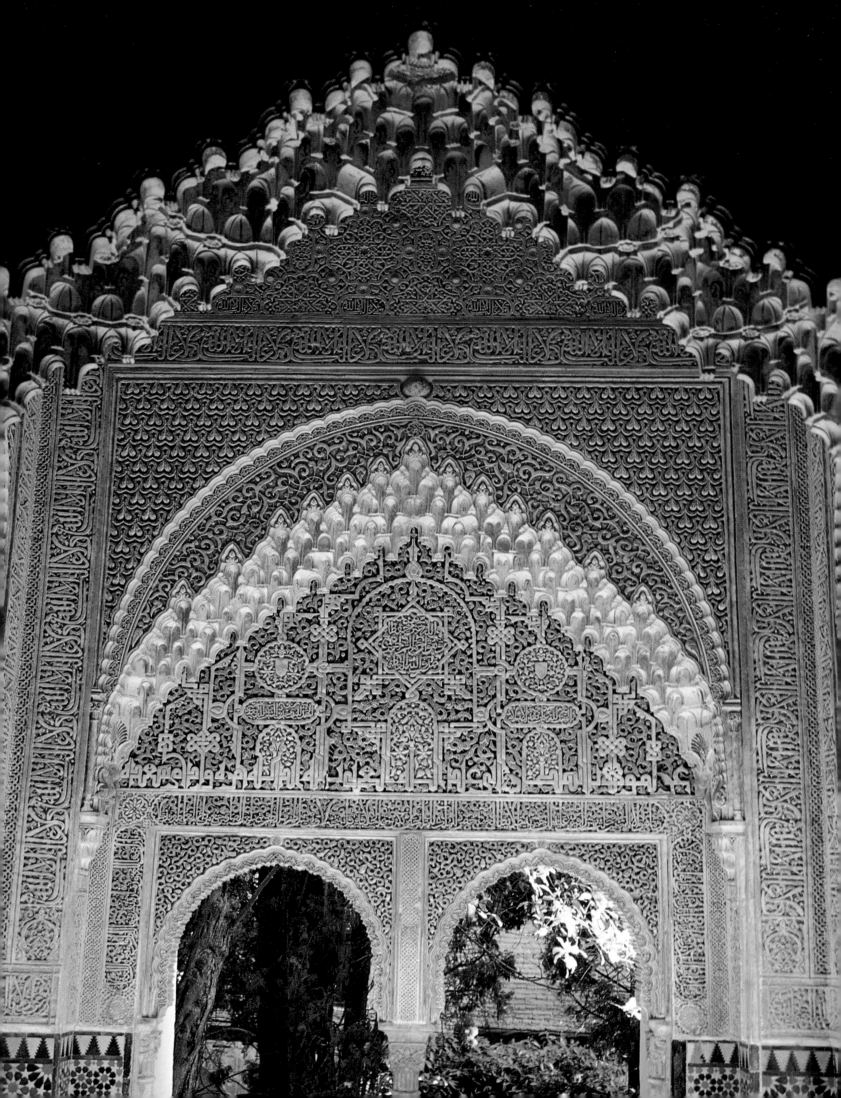

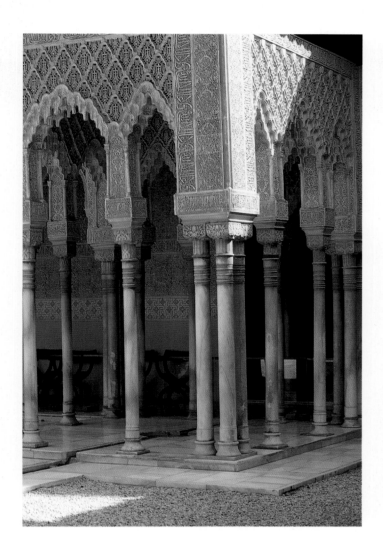

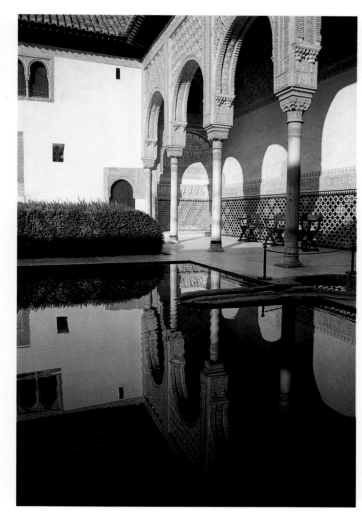

regale themselves with *bocadillos* stuffed with Trevélez ham, apparently

unconcerned by the thought of putting on weight. At siesta time, the city

centre empties, leaving to visitors the joys of exposing their shoulders

around the cathedral and the Alcaicería. The pedestrian streets along the

Rio Genil, in the vicinity of the Plaza Mariana Pineda, are then the haunt

of good-natured old people and children, the former scornful of the

passage of time, the latter frittering the hours away.

It must be said that Granada has made a better job of its forced marriage

with Castile, with Christianity, with Spain as a whole, than other

Andalusian towns. In its cathedral, behind the wrought-iron grilles of

the Capilla Real, lies the oldest symbol of the nation's unity: the Carrara

marble tomb of Isabel of Castile and Ferdinand of Aragon, whose

Always open to the world outside, the patios of the palace are surrounded by arches supported on slender columns. Their beauty is enhanced by the play of light and shade produced by sunlight and its reflection on water.

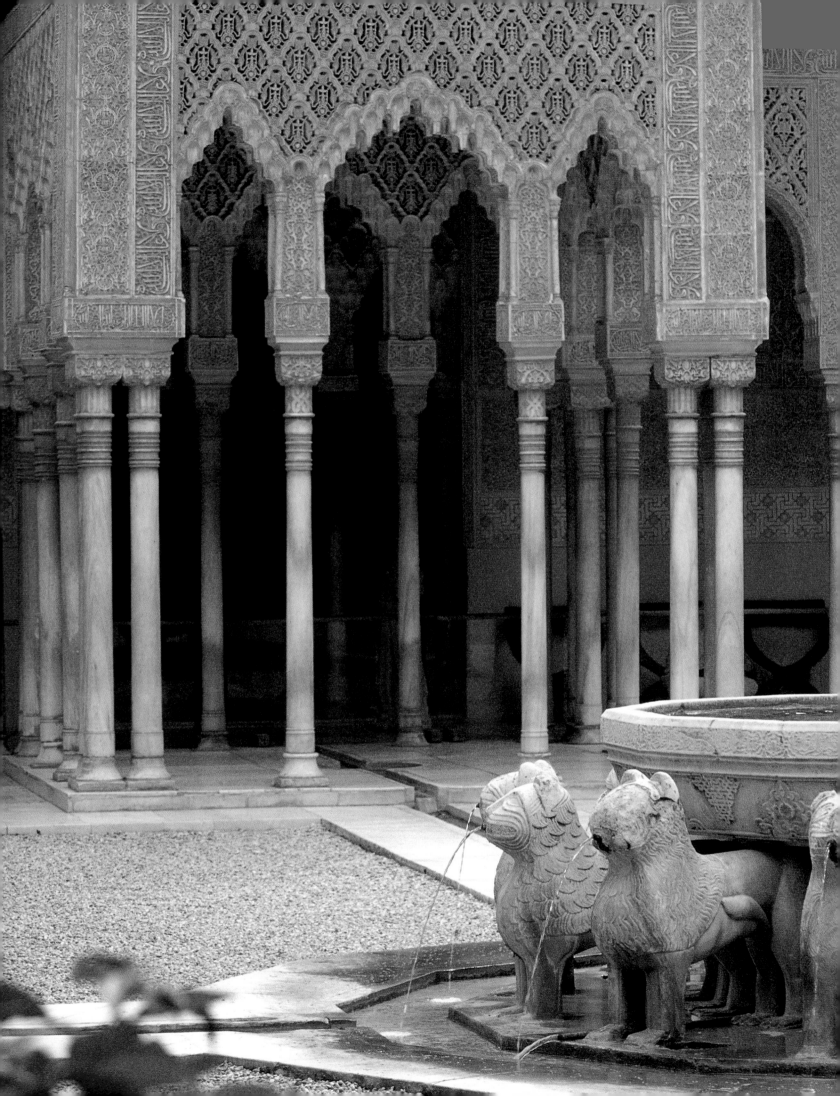

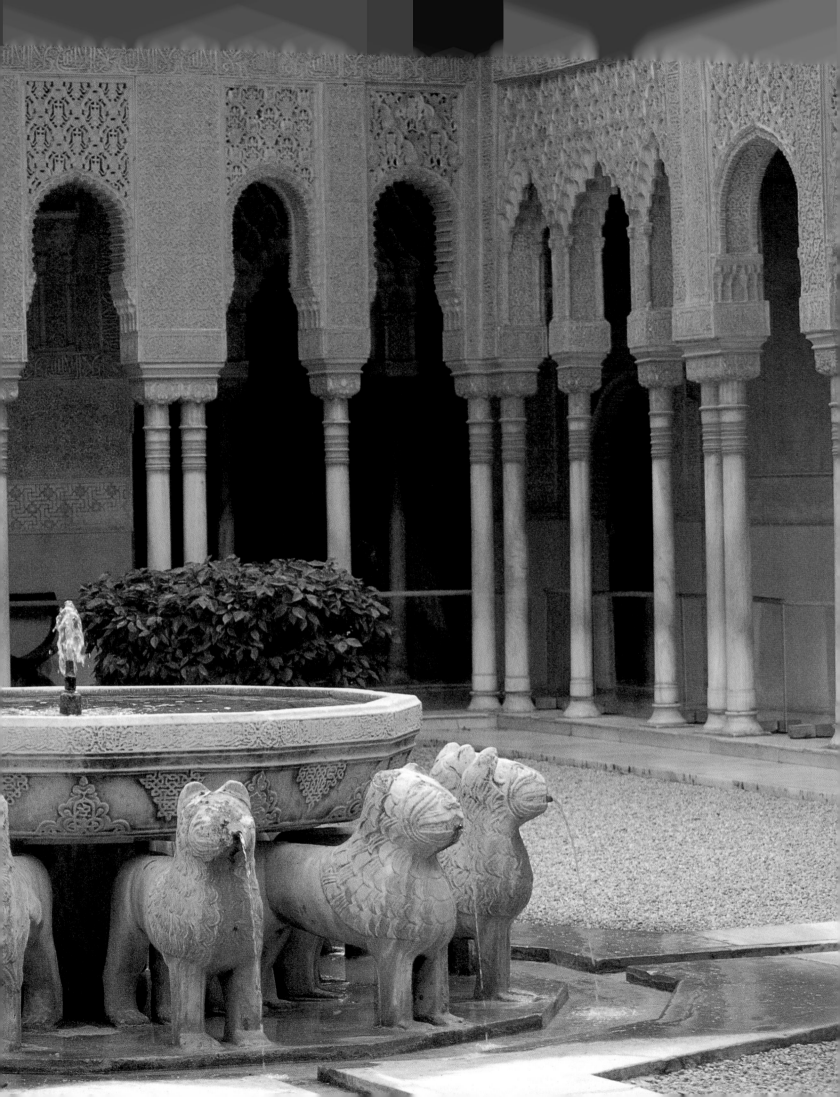

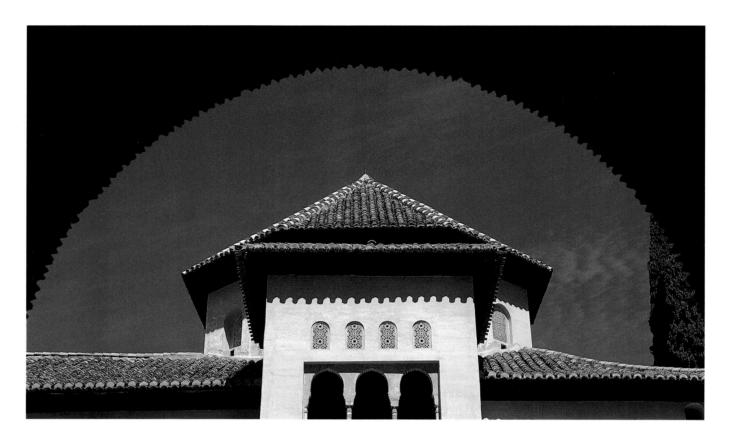

marriage and exceptional destiny was the driving force of unification. Spanish, Catholic Granada extends northwards towards the university districts, its faith displayed in church doorways. In the streets adjacent to the Gran Vía Colón, lined with opulent turn-of-the-century buildings, the chapel of the San Juan de Dios hospital and the monastery of San Jerónimo groan under a weight of gold, mother-of-pearl, and marble sculpture. A stroll in search of Granada's Baroque treasures culminates with the truly amazing Cartuja, in the most northern part of town. Every inch of stonework is embellished with stucco, paintings, or statuary; every pillar is adorned with barley-sugar columns framing gilded virgins or chubby cherubs.

This is the pious, conservative face of Granada. But the city has recently rediscovered its more progressive side, remote from the tasteless superstition of the Sacromonte caves. Lorca's plays are being performed again – proof that the city has not lost the pride and critical faculty of its favourite poet and dramatist, who lived here and loved the place to the

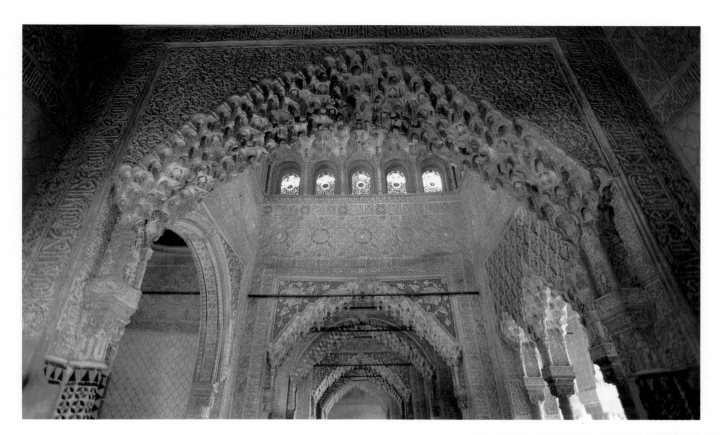

extent of risking his life to return at the outbreak of the civil war. Federico García Lorca, captured in Granada in August 1936, died in a hail of Phalangist bullets. He was murdered on the steep, little-frequented road to nearby Viznar, or maybe in the village square – it is a mark of their shame that chroniclers have pretended not to be sure – on the night of 19 August of that year. He had a great fondness for this city and its countryside, which were the inspiration for his plays. In the 1920s, he organized with his friend the composer Manuel de Falla a festival of *cante jondo* which was a turning point in the development of flamenco. He fed on the local legend of Mariana Pineda, executed in 1831 for having denounced the prevailing regime, and made her the protagonist of one of his plays. Of this heroine embodying purity and courage, he wrote: "When I imagined this ideal figure, the Alhambra was a moon adorning her breast, the Vega embroidered in a thousand shades of green was her robe, the snow of the Sierra her white petticoat standing out jaggedly against the blue sky."

Yussuf I (1333–1354) and his son, Muhammad V (1354–1391) built their palaces around the Court of the Myrtles and the Court of the Lions. Marble paving, azulejos, sculptured plaster, and wooden partitions were the simple materials preferred by the Moors, used to good effect in the Hall of the Kings and the Torre de Comares.

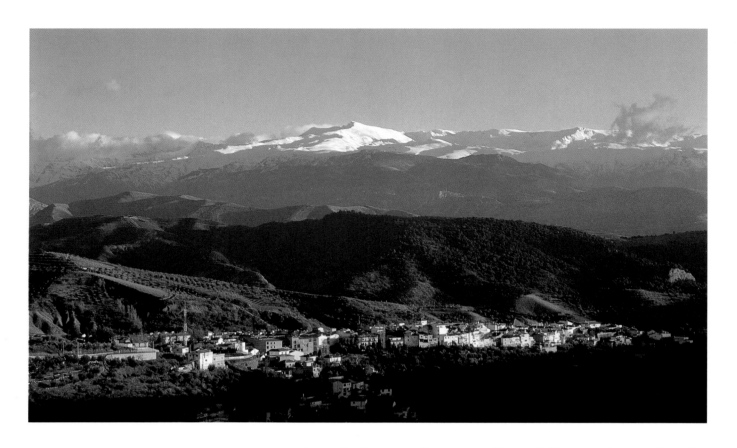

In a hollow of the northern slopes of the Sierra Nevada, a harsh light is reflected on villages built in austere natural surroundings. The ghostly Renaissance castle of La Calahorra has a power which rivals that of its mountain setting.

It bears the fine-sounding name of "Nevada" because its proud profile, dazzling Granada with reflected light, is snow-covered all the year round. If you travel by car, barely an hour of hairpin bends on Spain's highest road separates the sweltering heat of the plain from its fourteen chilly summits. They are all something over 3,000 m (9,840 ft), culminating in the Mulhacén (3,478 m/11,410 ft). On the other side, only 35 km (22 miles) away as the crow flies, lies the Mediterranean, its ultramarine depths relieved by fluffy white breakers. The Pico de la Veleta (3,431 m/11,256 ft), lazing in a sea of cloud, looks down upon Castile to the north and the Rif Mountains of Morocco to the south, passing the time of day with the royal eagle as it circles majestically above the pines, gentians, and snow violets.

The Alpine flora and fauna come as a surprise in so sunburnt a land. For this reason, they are carefully preserved in a nature reserve extending east to west over 136,880 hectares (528 square miles), which for over thirty years has served as a venue for winter sports and world

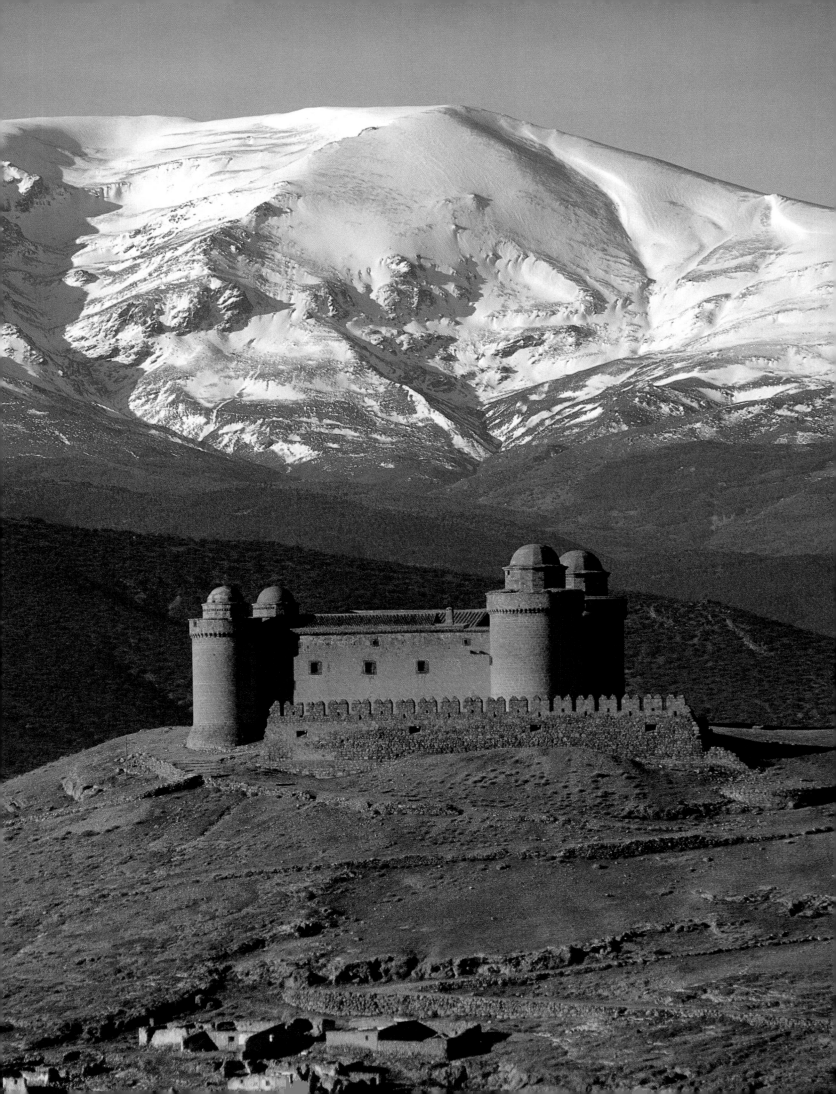

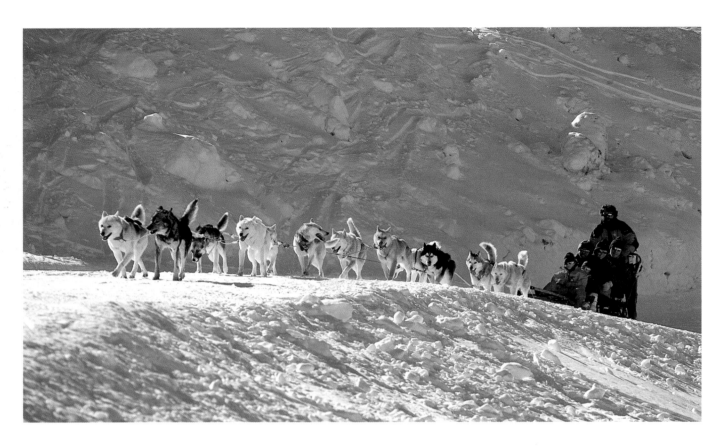

Dog-sleigh enthusiasts take advantage of the Sierra's year-round snow cover. There is good skiing to be had around the Pico de la Veleta, which rises to 3,431 m (11,256 ft).

skiing championships. You will come across dog sleighs and snowboard fanatics, and from December to April the better-off citizens of Andalusia criss-cross drifts of snow freshly laid down by the ultra-modern equipment of the *Solynieve* ski resort. With a reliable supply of "sun and snow", the pistes of Pradollano are in no way inferior to the most fashionable Alpine resorts, and their popularity means you may have to book well in advance.

Here, exotic equates with cold. And in summer, to avoid the annual rush to the coast, adventurous spirits are discovering the more shaded valleys cut by rivers on the southern slopes of the Sierra: the Alpujarras. Remote and cut off, these heavily eroded hills have provided shelter for all the rebels Spain has thrown up: from the Moriscos, who continued their struggle against the Catholics until 1609, to the Republicans, who proved their aged firearms on Francoist targets during the civil war. The broken terrain has always sharpened the instinct to resist. To savour the charm and wildness of this region,

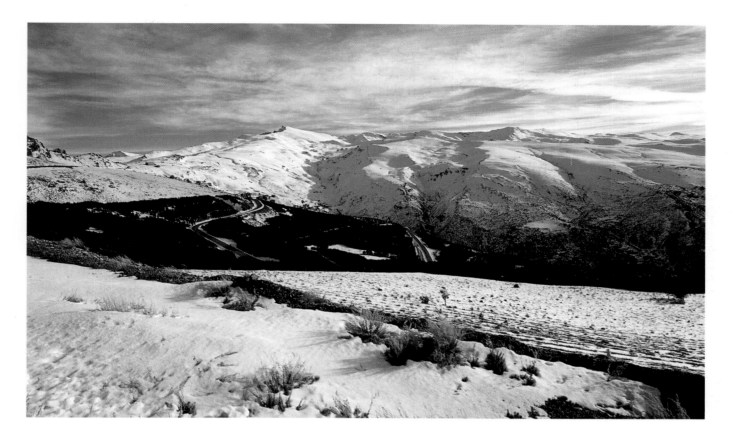

take the only practicable tarmac road, from Granada to Motril on the coast, and branch off eastwards when you get to the half-way point. This route also crosses the Puerto del Suspiro del Moro (Pass of the Moor's Sigh), where the last of the Moorish kings looked back and bade his final farewell to Granada. From Lanjarón to Ugíjar, the lime-washed villages of interlocking flat-roofed houses cling to steep rocky terraces relieved by shrubby vegetation. The sandy-grey roof tiles, containing powdered slate, are reminiscent of the little villages of the Moroccan Atlas. Shaded by oaks and sweet chestnuts, the inns of Pampaneira, Bubión, Capileira, and especially Trevélez – the highest town in Spain – have an attractive odour of dried serrano ham, sun-ripened oranges, and brook trout.

Returning north, the most amazing apparition in this unforgiving sky is the castle of La Calahorra, assailed on its bare mound by the mountain winds – a Renaissance parody of Wuthering Heights.

Even the most placid travellers

must sometimes be overcome

by a longing for the Mediterranean and the Costa del Sol.

The
MEDITERRANEAN COAST

The eastern headland of the Golfo de Almería is part of a nature reserve, created in 1987 to protect the adjacent coastline. The Cabo de Gata reserve covers an area of 26,000 hectares (100 square miles) and is home to 170 species of bird. Inlets of volcanic rock are lapped by the crystal-clear coastal waters.

For starters, why not take a bottle of mineral water, *con gas* or *sin gas*, and venture into Spaghetti Western country? In the desert around Tabernas, the temperature is 40°C (104°F) in the shade – if you can find any; the air shimmers in the oppressive heat; and in the hollow of lunar canyons the pebbly stream beds have not seen a drop of water for months. This is where Clint Eastwood and Henry Fonda rode out to make *A Fistful of Dollars* and *Once upon a Time in the West*, and Peter O'Toole sweated under his headdress in the role of Lawrence of Arabia. The film stars have come and gone, but the sets remain and it does not take much imagination to see the balls of tumbleweed rolling towards the half-open doors of the silent saloon in anticipation of the final shoot-out. Then drive back the 30 km (18 miles) to Almería, on the edge of the inviting blue expanse of the Mediterranean, and take an invigorating plunge in the salty, liquid element.

Almería, with its 161,560 inhabitants, is still the embodiment of Andalusian poverty. And maybe this explains why it still has a soul, unlike much of the rest of the coast. It was this proud quality that enabled it to hold out for the Republic until 1939, to the chagrin of Hitler, who for two years had been sending squadrons of bombers in

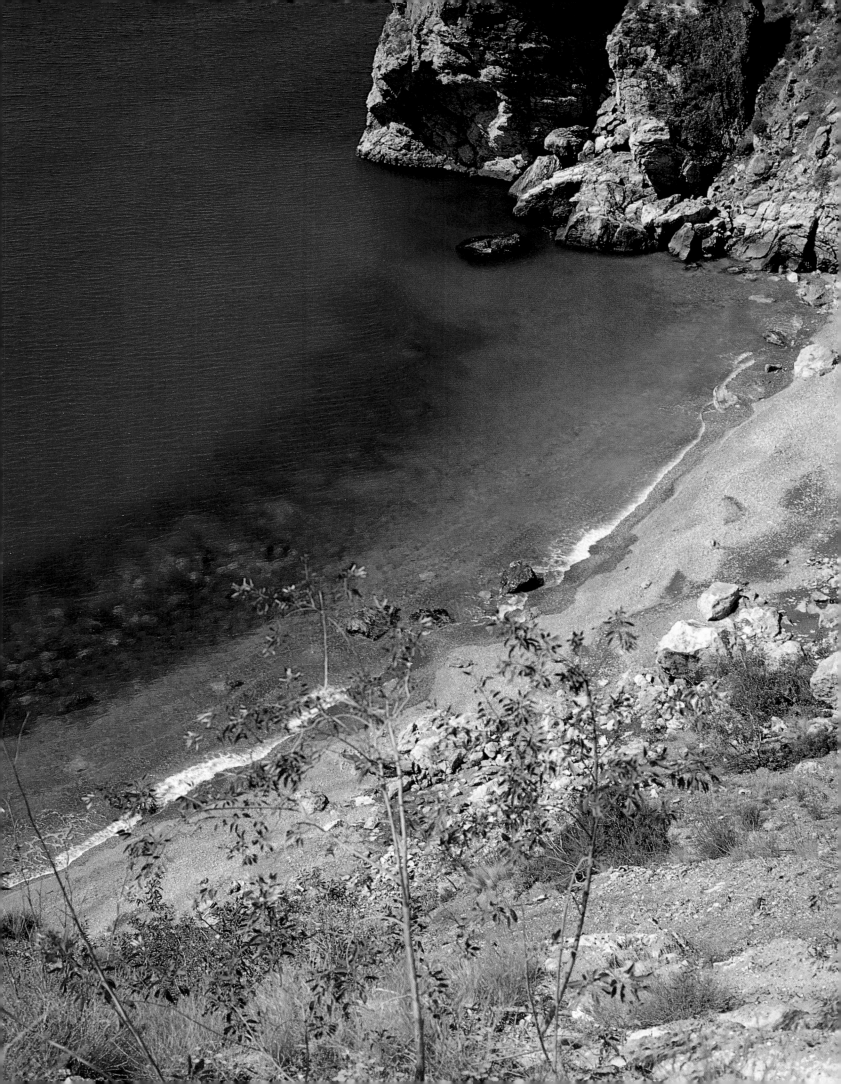

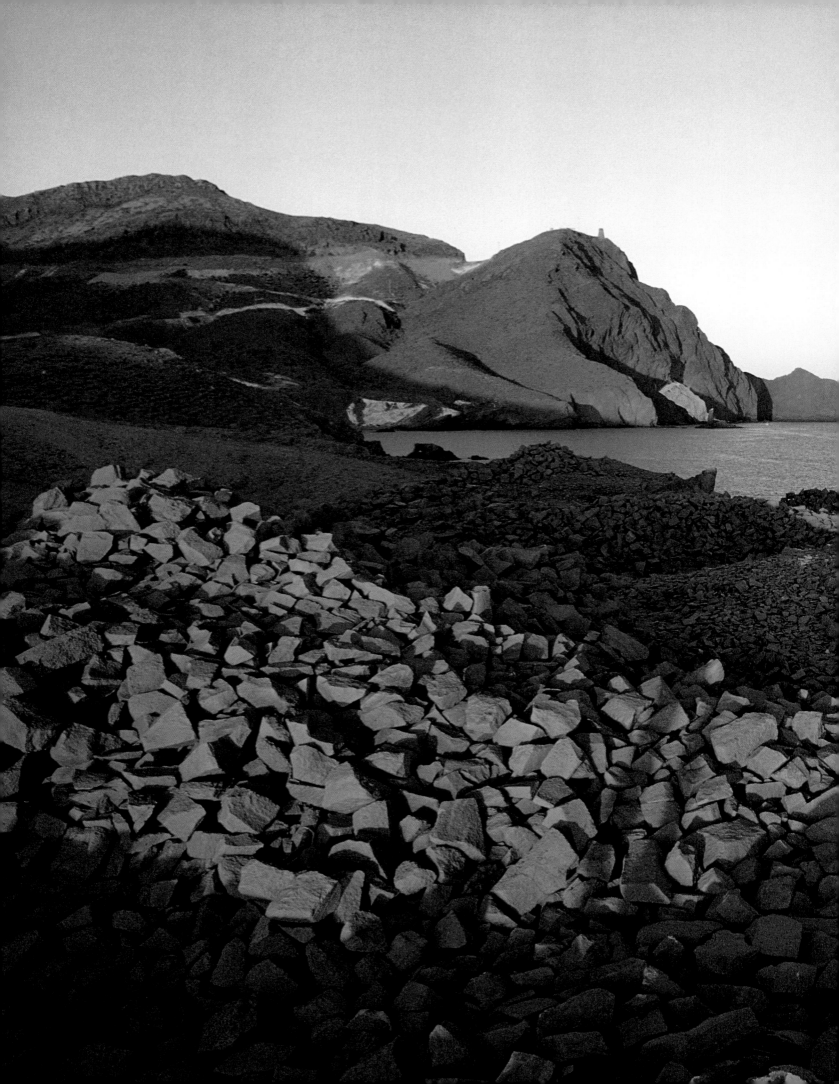

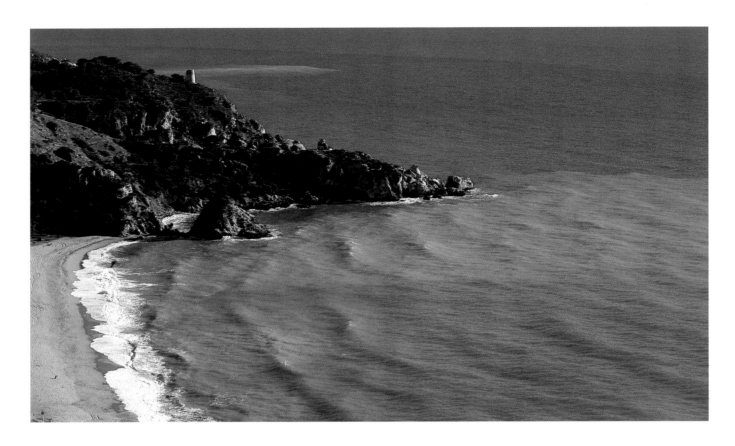

Between Almuñécar and Nerja, the cliffs of the Sierra Tejeda plunge sharply into the sea. The narrow roads of the hinterland lead to sleepy villages and aqueducts carrying water around the mountain sides.

support of Franco. Its port, the haunt of part-time gypsy stevedores, handles only limited traffic because of a dearth of local industry. In town, ancient terraced lanes contrast with hastily built, pretentious, glass-and-concrete office blocks. The local economy is based on market gardening, and the plastic-covered greenhouses stretch away endlessly westward under a leaden sky. But there is also singing and dancing on the beach in honour of the Virgen del Mar. And a visit to the Alcazaba, Spain's most extensive Moorish fortification, is a fascinating experience – but remember that you should not leave your car parked too long in the La Chanca district.

Another redeeming feature of its poverty is that Almería has been neglected by the property speculators, and its bay and the Cabo de Gata nature reserve, created in 1987, are a naturalist's paradise. A strip of coastline 2 km (1 mile) deep and 26,000 hectares (100 square miles) of marshland, volcanic rock, and dunes has therefore been spared the disfiguring scars of mass tourism. In the red-rocked inlets, the sun tries

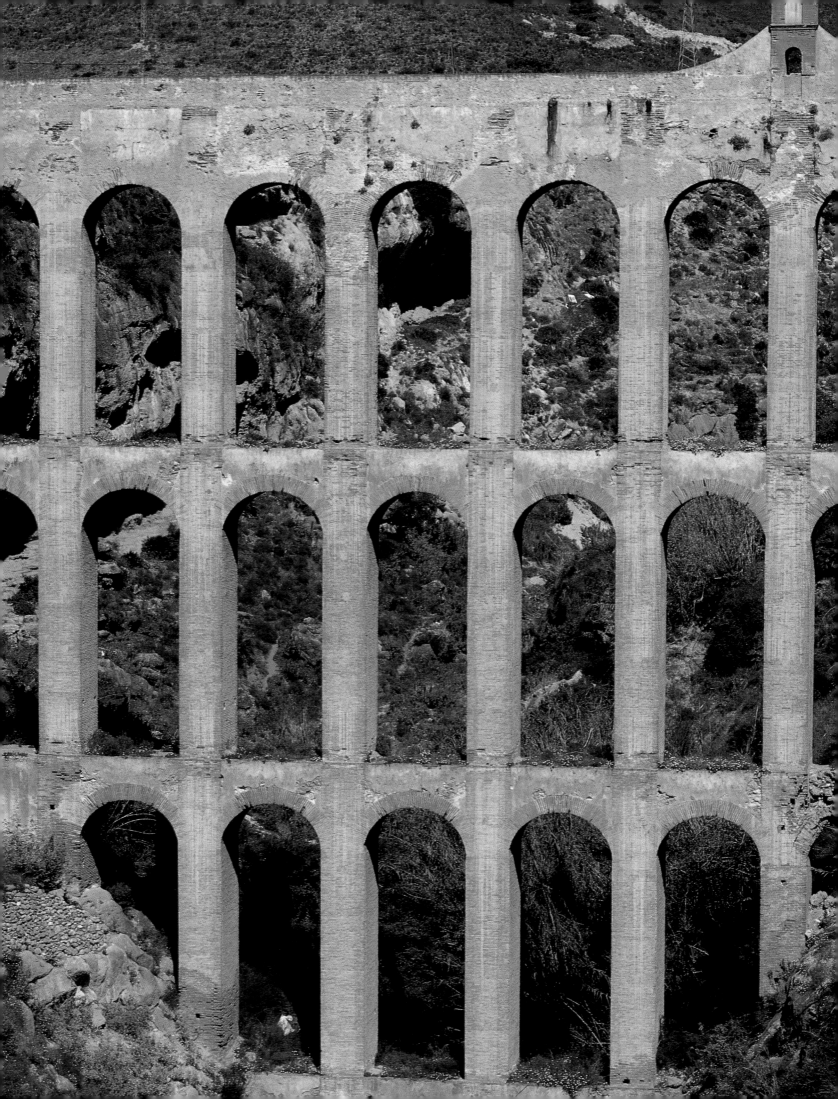

*T*he gardens of Churriana, near
Málaga, provide a cool shade all the
more welcome on the Costa del Sol,
whose ribbon of urbanized beaches
stretches from Málaga to Estepona.
Millions of holiday-makers come
here to acquire a suntan.

in vain to unravel the jade hem of this rippling indigo banner. At the

foot of the cape, near Mermaid Rock, scuba divers glide among the

sponges, awaiting the planned reintroduction of white-bellied monk

seals, absent for the last twenty years. This virtually unspoilt biotope is

home to some 170 species of bird, including the pink flamingo and the

griffon vulture.

The return to package-holiday civilization can be made in homeopathic

stages, following the 370 km (230 miles) of expressway which run from

Almería to Algeciras, beyond the defiantly British rock of Gibraltar. The

section of coast as far as Almuñécar, known as the Costa Tropical on

account of its even-tempered climate and the distant memory of sugar-

cane plantations, is now dotted with plastic-covered enclosures, where

tomatoes and citrus fruits swell and ripen apparently overnight.

Between the coast road and the sea, you will occasionally see little

fishing ports, like Rabita, which have retained their authenticity. From

Salobreña, wild nature at last begins to reassert itself, and from

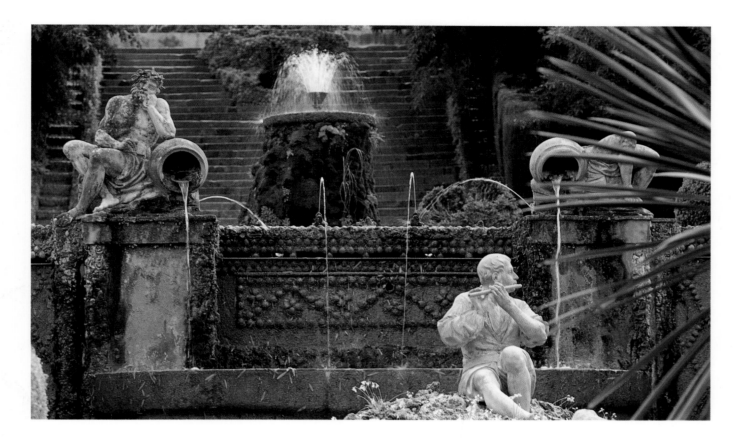

Almuñécar to Nerja the mountains sweep down majestically to the sea. Bearing witness to former days, Salobreña (9,500 inhabitants) remains an oasis of authenticity in a desert of flashy imitation. Rising from the sugar-cane fields, the town and its Moorish castle seem to hover between sea and sky. A thicket of small white houses and bluish shadows spills over the shoulders of its tranquil hill, punctuated at every level by a stifling weight of crimson flowers.

The luxurious villas of nearby Nerja cling to the steep slopes surrounding the celebrated *Balcón de Europa*, a rocky promontory forming a theatrical belvedere from which to gaze out towards the African coast. Again, the old village is virtually intact, but jam-packed in summer, as are the superb limestone caves for which the resort is best known. From here on, apart from the delightful little mountain road that ascends from Torrox to Salares in the Sierra de Tejeda national park, we are in sun-worshipper land. This is the realm of the all-conquering bikini, the grilled Scandinavian torso, and the blistering

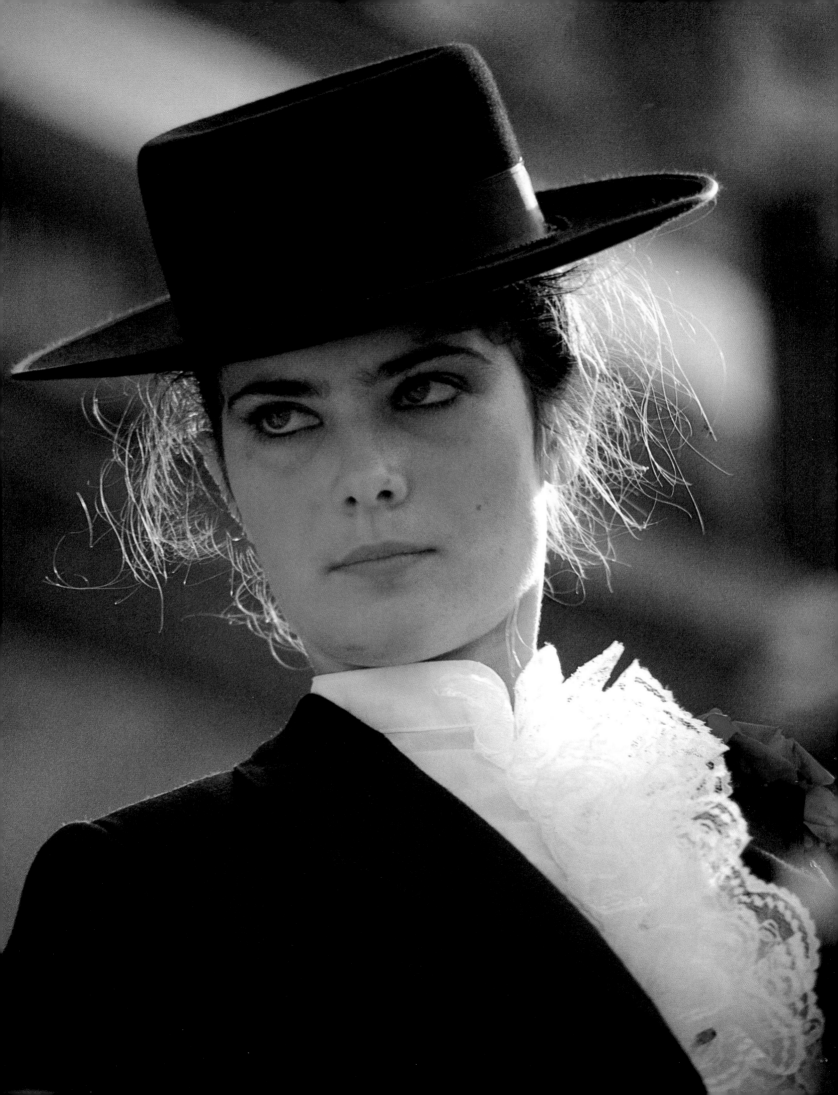

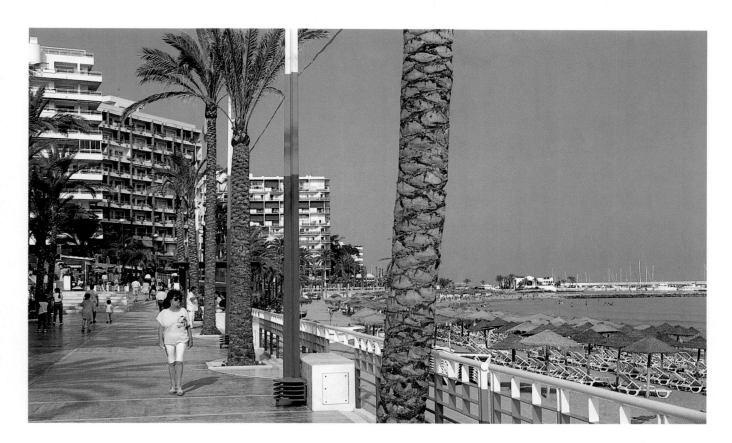

shoulder – an angry pink under its emergency application of suntan lotion until the regulation shade of ebony is achieved. The airport at nearby Málaga, chief town of a province of 540,000 inhabitants, spews out a steady stream of package holiday-makers, spreading them thickly along the ribbon of urbanized beaches between Torremolinos and Fuengirola, Marbella and Estepona.

Málaga itself is a smiling town, always on holiday with its mild winters and busy nightlife. As a resort, it plays a more than adequate role. You can stroll between the palm trees of the Paseo del Parque and enjoy the cool of the fountains in the Alcazaba gardens. But the real star of the Costa – if between your *tapas* you must feast your eyes on open-air spectacle – is still the chic resort of Marbella. An outpost of Hollywood in the 1960s, when it was frequented by Frank Sinatra, it has since run through a fortune in Saudi petrodollars. Now, like the rest of the Costa del Sol, it is epitomized by the screech of shiny convertibles, most likely bought with the well-laundered profits of the drugs trade.

*T*he legendary Marbella is Spain's smartest holiday resort. The international jet set, petrodollars, and Rolls-Royces circulate freely in streets with luxury shops and two recently constructed mosques.
Following pages:
The desert of Tabernas, north of Almería, is the most arid landscape in Western Europe. Sergio Leone made use of its Arizona-like morphology in shooting his "Spaghetti Westerns".

• El Rocío •

On the Wednesday before Pentecost, an endless procession of rickety covered wagons, laden with flowers, converges on the hamlet of El Rocío, some 50 km (30 miles) south-west of Seville. The men, their belts anchoring billowing white shirts, sweat freely under their broad-brimmed sombreros. Their womenfolk ride pillion, hair pinned with combs set off with a red carnation, and flounced skirts falling over the horses' hindquarters. Spain's biggest pilgrimage, the Romería of El Rocío, is also the most extravagantly colourful and joyful of the country's religious rituals. Every year, the authorities worry lest this motley gathering gets out of hand. They are wasting their time. Brawls are all part of the fun, and certainly do not discourage the million or so pilgrims from making the trip. As well as gypsies from the local area, the festival attracts caravans from all over Spain, and from northern and central Europe. For the gypsies themselves, this long journey is a return to their origins, to their ancestral nomadism. But the Romería also draws a hundred or so religious brotherhoods from the area around Cádiz, Huelva, and Seville. The pilgrims cross the marshes of the Guadalquivir delta on foot, or in some cases by boat, to reach El Rocío, on the edge of the Doñana national park. Around their encampments, they drink, sing, and dance. Throughout the night, the sound of tambourines and flamenco guitars is borne on the sand-laden wind. At journey's end, the normally undisturbed cries of waterfowl are drowned by the noise of the crowd hastening to worship its *Blanca Paloma*, the Virgin of Rocío. A crescendo of collective devotion is reached on the Sunday night and early hours of Monday. Sewn all over with gold, decked out in her Baroque necklaces, the dove of the marshlands is at last brought out of her sanctuary. To shouts of ¡*Que viva la Blanca Paloma!*, the Mother of God is carried in procession, the bearers stumbling through a sea of worshippers intoxicated with expectation, who finally lapse into unconsciousness as the first light of day begins to streak the sky.

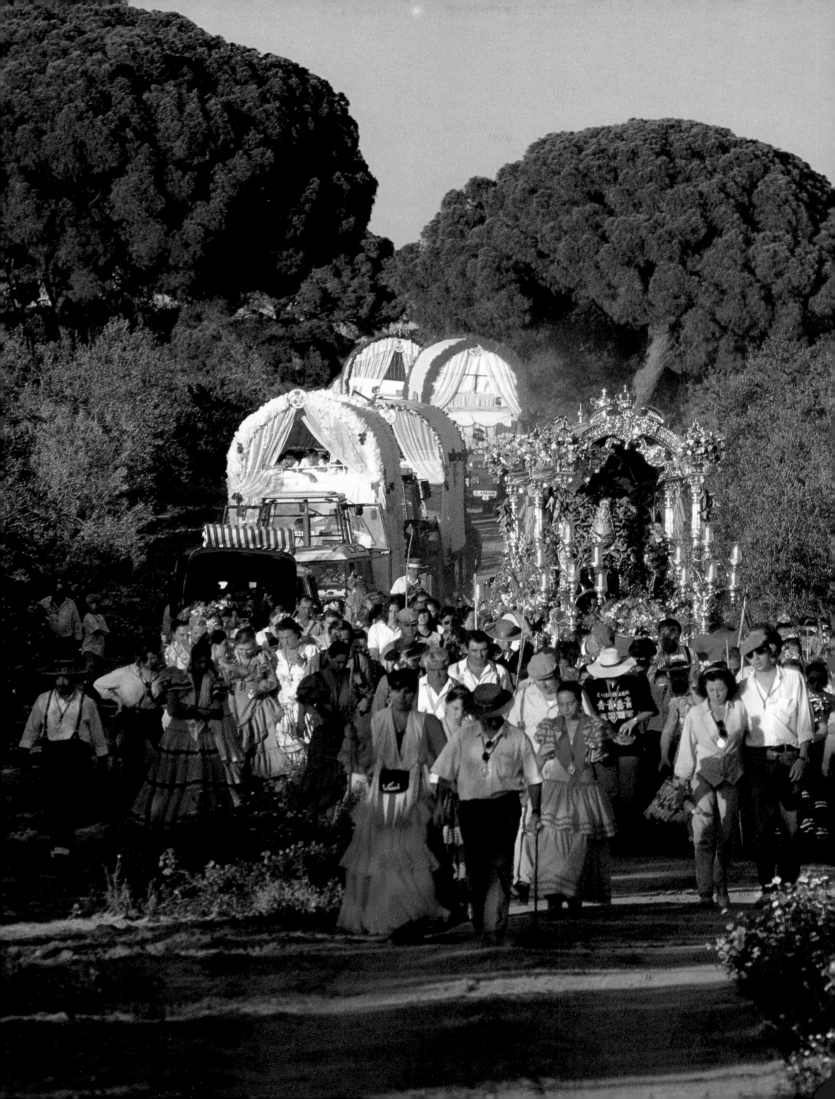

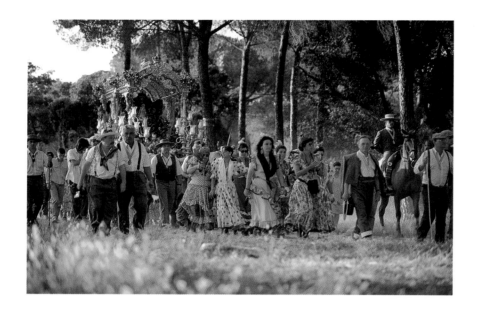

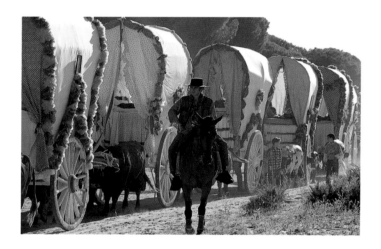

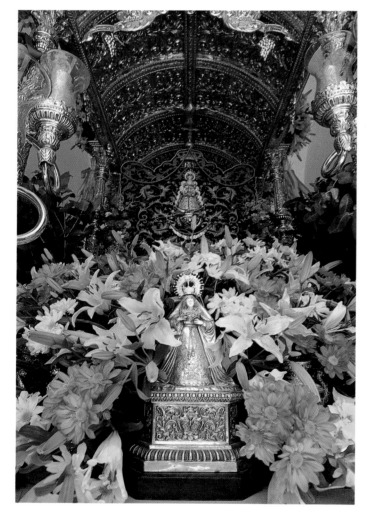

*D*rawn from Spain and all over
Europe, a colourful multitude of
gypsies in flower-decked wagons
join with members of religious
brotherhoods each Pentecost to
venerate the effigy of the
Virgin of Rocío.

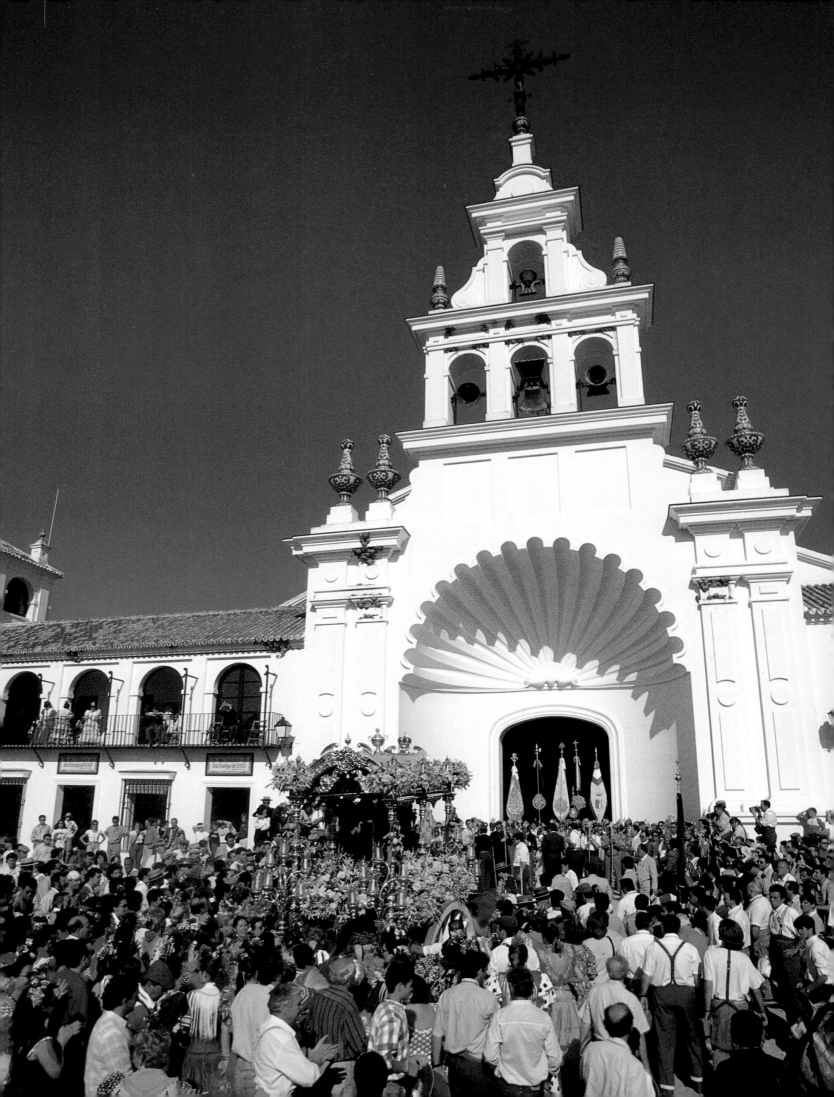

The hinterland of south-west Andalusia
has always captured the imagination
of foreigners fascinated by Spain.

THE WHITE VILLAGES

Built on two rocky promontories, protected by ramparts and ravines, Ronda was not wrested from the Moors until 1485, by Ferdinand the Catholic.

The fascination is justified, for nowhere is life so conditioned by landscape, nor are people so humbly wedded to earth, climate, and sun. Mountain ranges unspoilt by the modern world – in some places desolate, elsewhere clothed in luxuriant vegetation – are dotted with agricultural towns and villages of a dazzling whiteness. Suffused with light from a pure blue sky or brushed by the cumulus clouds announcing a downpour, sand-pink roofs and Moorish ramparts appear at the turn of a hairpin bend. Romantic and bitter, the torn landscape ensures isolation and rusticity. The names of the villages are followed by the expression *de la Frontera*, as once, before the fall of Granada, they marked the division between the Christian and Muslim worlds. A tour of these parts is a journey back in time, where each rocky spur colonized by modest white houses is a page in the history of Muslim resistance to invasion. The emphasis today is on the continuity of tradition, rather than the dramatic events of those times. Even tour operators, who always go for eye-catching names, simply refer to the triangle between Arcos de la Frontera, Ronda, and Jimena de la Frontera as the *pueblos blancos*, the "white villages".

This is a world of pure tranquillity and natural splendour – a landscape of harsh hills and deep-cut valleys, rivers, lakes, and

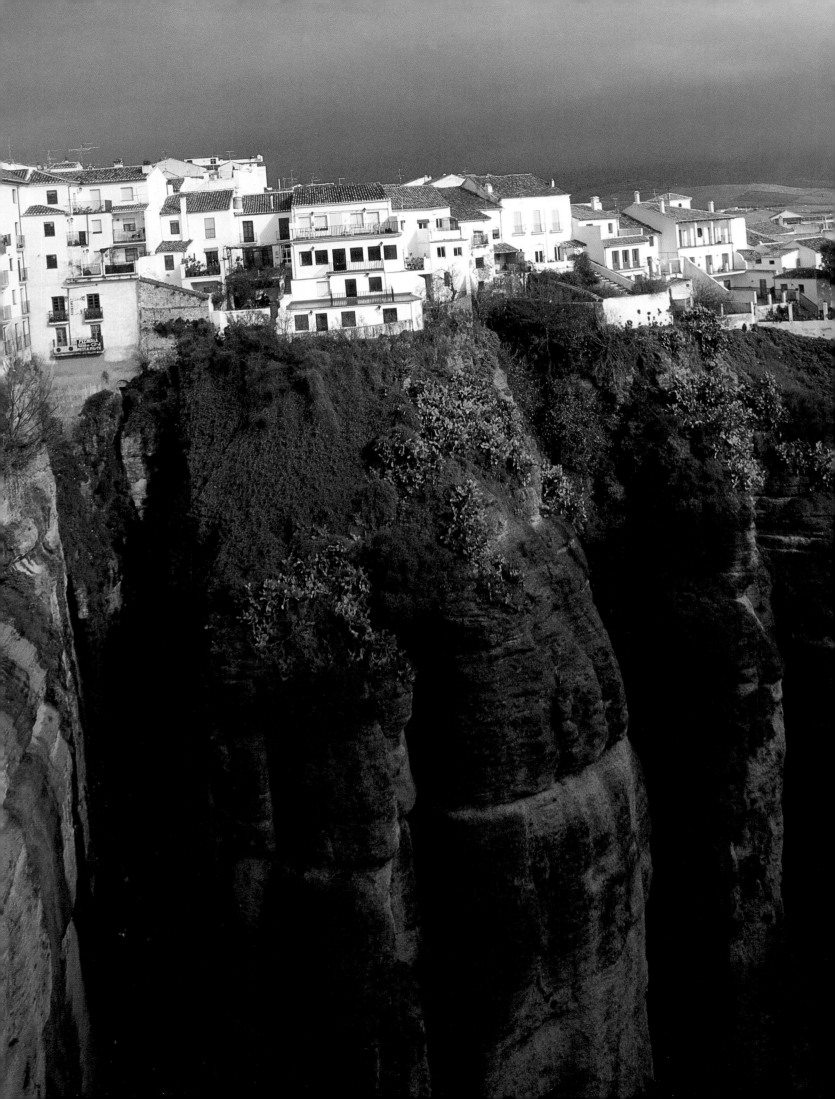

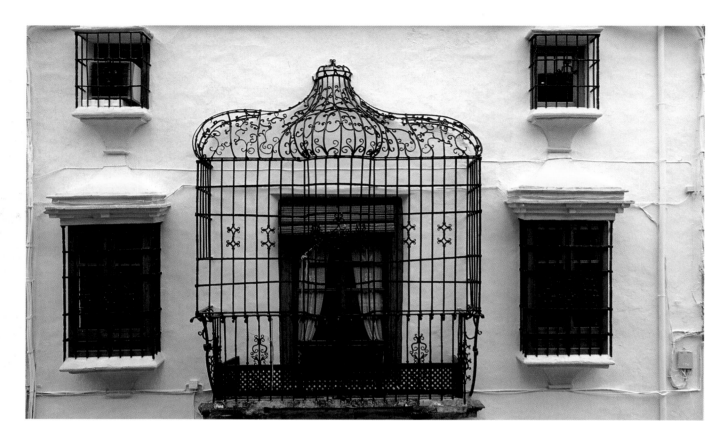

dams, which also has some of the heaviest rainfall in the whole of Spain. You need to come back several times, as there is so much to discover. And do not always take the same road. You need to explore them all, come back the other way, find new vantage points from which to observe the whitewashed villages clinging to the hillsides, peer into verdant valleys, and survey arid slopes. If you have to choose, take the winding tarmac roads following the sierras of Grazalema, Margarita, and Ubrique: the A382 from Arcos to Olvera, the C 339/A 376 from Algodonales to Ronda, the A 369 from Ronda to Jimena, and the C 3331/A 375 from Jimena to Ubrique. As always, the formal precision of the road map never reflects the rugged beauty of the landscape. And, at altitudes of 1,500 m (4,900 ft), be sure to wander on foot in the green, game-rich undergrowth of the Sierra de Grazalema and Alcornocales nature reserves. Spend an afternoon watching the circling eagles. Relax to the constant rumble of the Salto del Cabrero waterfall,

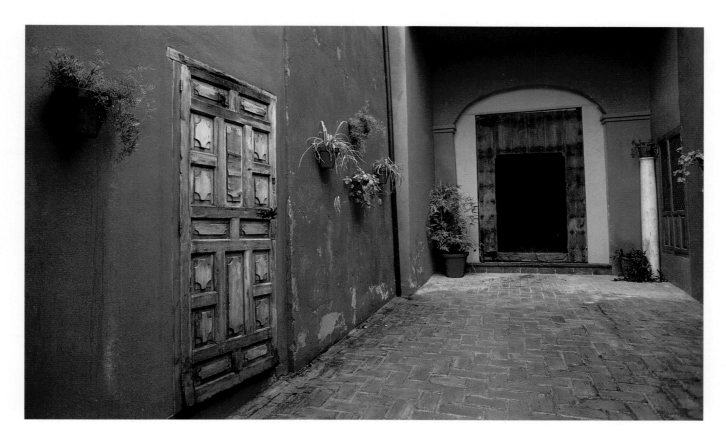

and doze in the shade of a *pinsapo* fir tree, a protected species that has survived from the late-Tertiary Era.

When the shadows lengthen, it is time to make your way back to the road, body totally relaxed, stomach just beginning to grumble, and search for a welcoming *taverna*. The first terrace of a village square just stirring from its siesta will do perfectly well. There you are greeted by the maternal smile of a mountain woman turned inn-keeper, who modestly proposes a few *raciones* of the local fare. The ham has a salty aroma, an aftertaste of sunburnt maquis with a hint of storm-drenched soil. In the empty alleyways, the stifling silence is broken only by the scrape of sandals and syncopated laughter of racing children with caramel cheeks. It is all very different from Arcos and its bustling rival, Ronda. Here in the remoter villages seasonal employment is immensely attractive to the younger generation, more interested in earning some ready money than helping the family in the fields.

Ronda's enclosed courtyards and closed windows protected by black wrought-iron grilles are characteristic features of an Andalusian town deeply marked by its Muslim past.

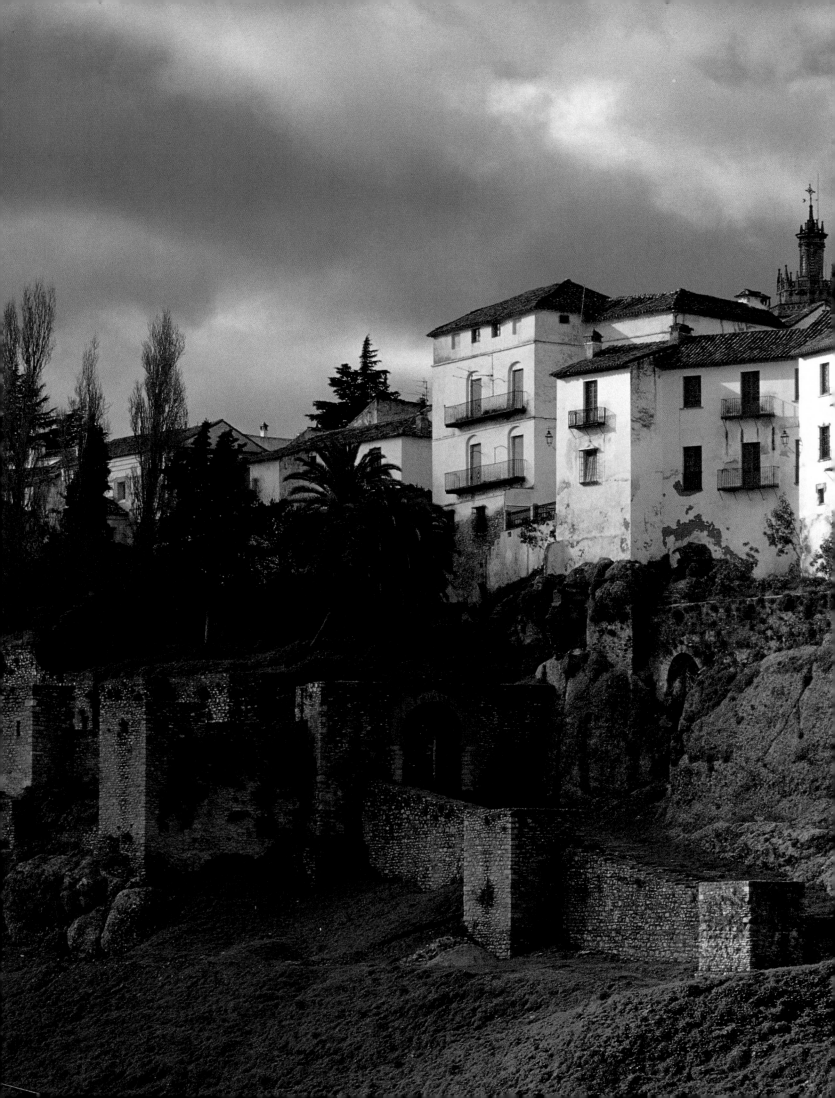

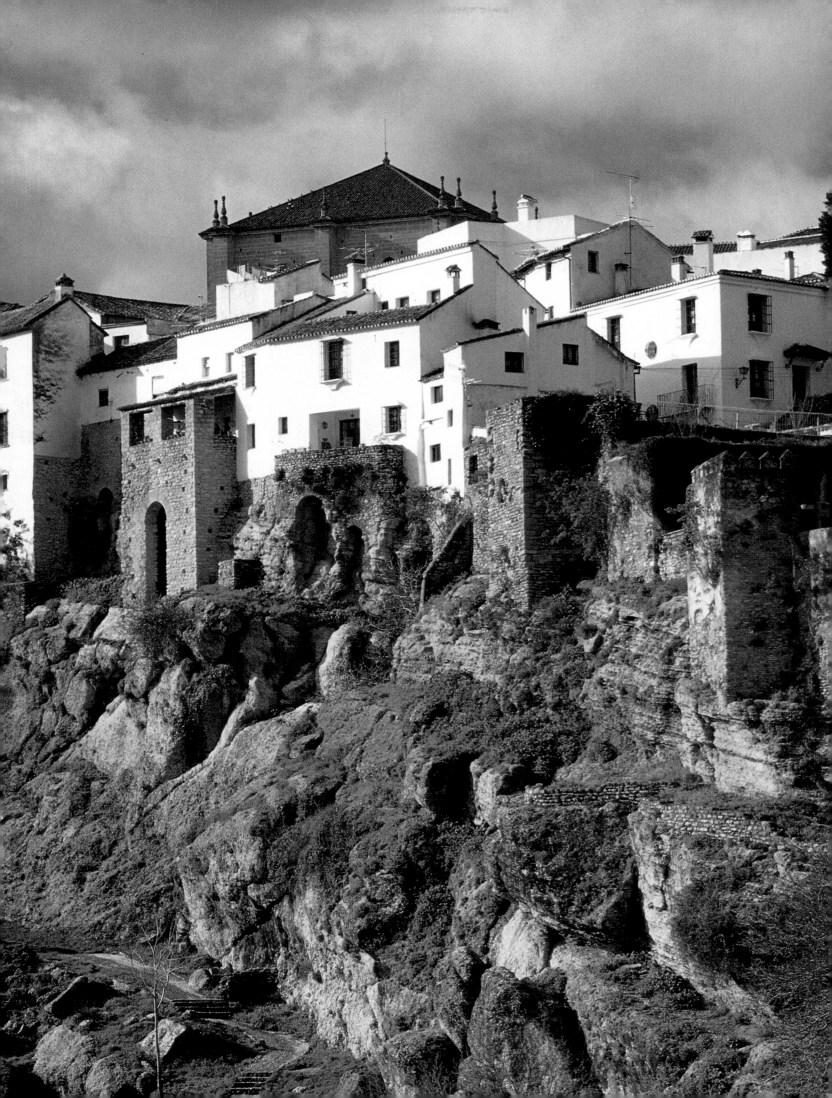

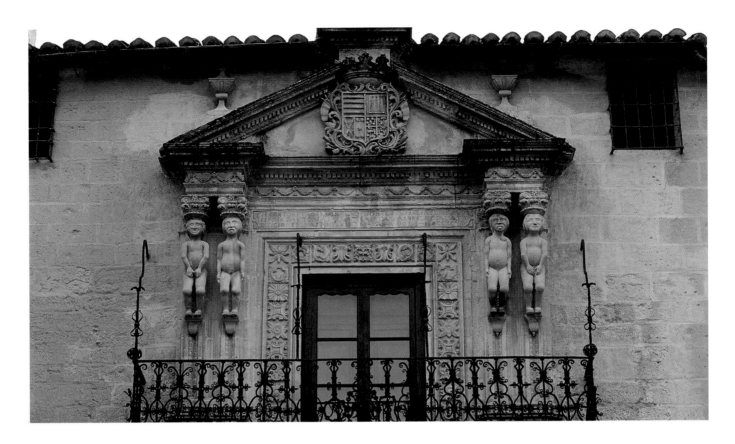

In the heart of the old town, known as La Ciudad, the balcony of the Palacio del Marques de Salvatierra, the Carlos V arch, and the patio of the Palacio de Mondragón are all of Renaissance origin.

It is at *Medina Arcosch*, which became Arcos de la Frontera in 1250 when Alfonso X wrested it from the Moors, that the excitement of discovery begins – an excitement renewed at regular intervals, as another village comes into view every 20 to 30 km (12 to 20 miles). Arcos itself (27,000 inhabitants), hanging over a bend in the Rio Guadalete, gives the impression of a schooner with swelling mother-of-pearl sails beached on a fortified reef. Its bottom torn out by the impact, the ship pitches among the honey-coloured rocks, and comes to rest in a long slide of immaculate little houses. In the main square, the three bells of the Baroque church of Santa María ring out over the immensity of the slumbering plain below. Further on, between Bornos and Villamartín, a vast man-made lake reflects the same virginal light, the same dazzling sky, which weigh down on sleeping convents and the silent doors of leather-workers' shops. At Algodonales, which specializes in furniture-making, the main road turns north into the Líjar massif, heading

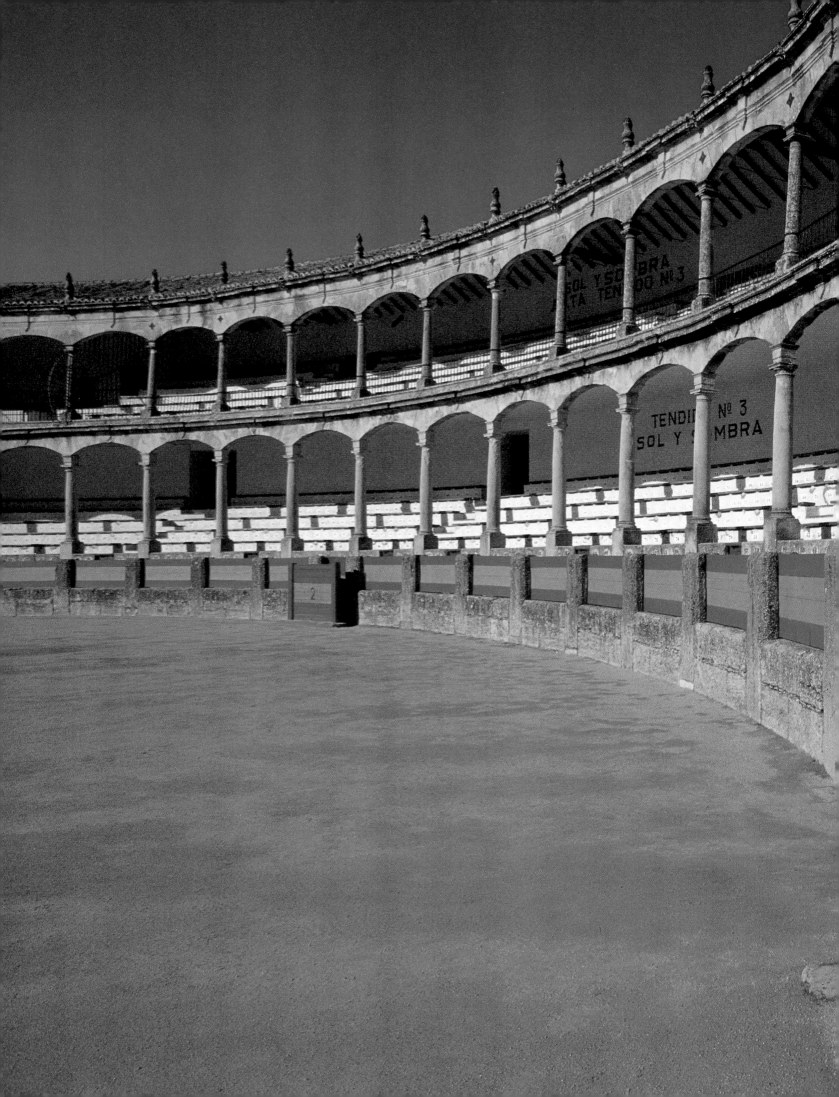

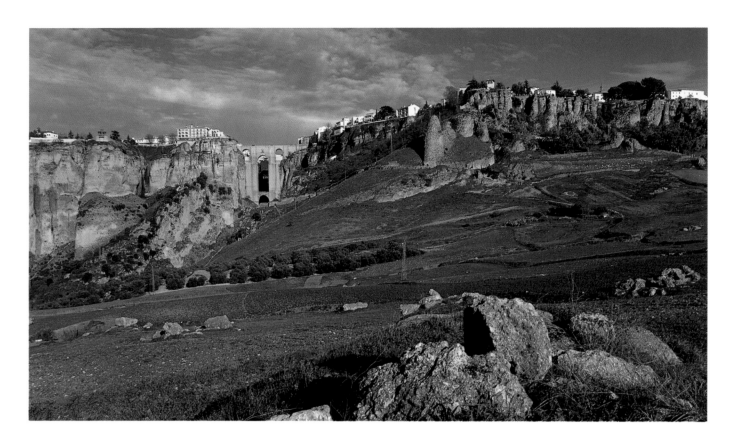

The two parts of the town are separated by the tajo, a deep cleft bridged by the Puente Nuevo. Built in the eighteenth century, it seems to grow out of the rock.

towards Olvera. Our route skirts the lake below Zahara de la Sierra, another whitewashed eagle's nest curiously straddling its rock. This stronghold, hotly contested in the frontier war between Castilians and Moors, was the prize that triggered the final assault on Granada; after the reconquest of Zahara, the Moors had unwisely attempted to wrest it back.

Further north, Olvera (9,000 inhabitants) seems to cope better with the uneven terrain, but the evidence of Moorish occupation remains: an impressive eleventh-century castle, under the constant surveillance of the equally towering church which stands opposite. Perhaps its severity is intended to silence any mention of the village's ancient vocation as a place of "diplomatic exile" for criminals on the run. Once they had crossed the frontier, and escaped the attention of their pursuers, they could enjoy their freedom in exchange for military service on the other side. From Olvera, a potholed minor road follows the Rio Trejo to Setenil.

Unusually, this village is sited in the valley, its main street of cave dwellings stretching along a deep gorge carved out by the river. Despite this succession of increasingly dramatic scenes, Ronda still comes as a surprise. It is difficult to say whether man was here bewitched by the mountains or vice versa. Certainly, Ronda is queen of the clifftops, and even the word "grandiose" barely does justice to the setting. The founders of the town (30,000 inhabitants) showed great daring in colonizing a natural limestone fortress, guarded on all sides by precipices. It is further defended by the providential moat of the Guadelevín. A hundred and sixty metres (525 ft) below, the river runs in a ravine 80 m (262 ft) wide, as if a giant had wanted to split the town in two. A dizzy bridge, welded to the rock, connects one "bank" to the other, and one imagines the cliffs on either side as petrified tongues protruding from the colossal eroded jaws of the Serranía de Ronda. There is no need to go into the technicalities of how the three arches of the

The church of the Espíritu Santo was built in the fifteenth century to celebrate Ronda's capture by the Catholic Monarchs.

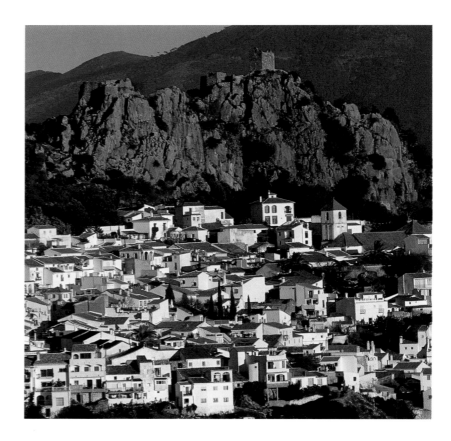

South of Ronda, on the road to Jimena de la Frontera, whitewashed villages come into view every few miles round a bend in the road. Here we see Benadalid, Algotocín, and Gaucín, clinging to the steep rocky hillsides.

Puente Nuevo were built, suffice it to say that it was a tour de force of late eighteenth-century engineering.

Not surprisingly, *La Ciudad*, the old town with its stony keep and neat citadel, held out tenaciously against the Castilian invaders. Ferdinand the Catholic finally took it by assault in 1485, but only after starving the defenders during a three-week siege. Almost everything about *La Ciudad* is reminiscent of its Muslim past: iron bars guarding the windows like the entrance to a *seraglio*, the Arab baths, the *mudéjar* patio of the Palacio Mondragón, and the staircase of the Casa del Rey Moro, where Christian slaves are said to have carried water up from the river to supply the needs of the Moors. Then there is the minaret-style tower of the enchanting Plaza de la Duquesa de Parcent, lazy and frivolous amid a riot of palm trees and oleanders.

To find the town's Christian heritage, you must cross the bridge and visit the Mercadillo district. Already inhabited at the time of

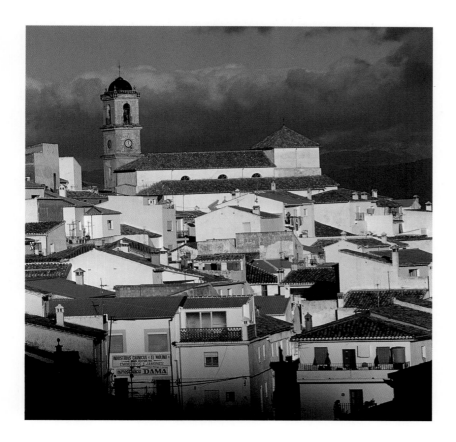

the Taifas, this part of town, like *La Ciudad*, was subject to "ethnic cleansing" after the Reconquest and settled by Castilians. Here you will also find Spain's most prestigious bullring, bearing witness to the Iberian love of the *corrida*, which was practically invented in Ronda – at least in its present form. Each detail of the art was perfected here by the Romero family; Francisco, born in Ronda in 1698, invented the *muleta* (matador's cape); his son Juan introduced the *cuadrilla* (troupe of bullring performers); and Pedro, the much-celebrated matador grandson, demonstrated the proper way of dealing the death blow.

But the Mercadillo has also inspired many other admirers of Andalusia and the peculiarly Andalusian approach to death as the great moment of truth. In 1912, the poet Rainer Maria Rilke stayed at the Hotel de la Reina Victoria, near the Alameda gardens. In 1984, Francesco Rosi chose Ronda as the setting for his *Carmen*. And Ernest Hemingway found the atmosphere so romantic that

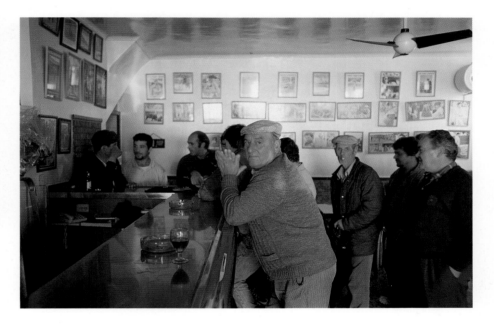

he advocated Ronda as a place to "spend a honeymoon or have a love affair" – not a bad idea, for in Ronda and the surrounding villages the heart vibrates with a quite new passion, as pure as the landscape itself.

True to their tradition of mountain agriculture, the sun-drenched, well-watered soils of the "white villages" yield an abundance of fruits and vegetables. The succulent local pork products have an unmistakable, authentic flavour.

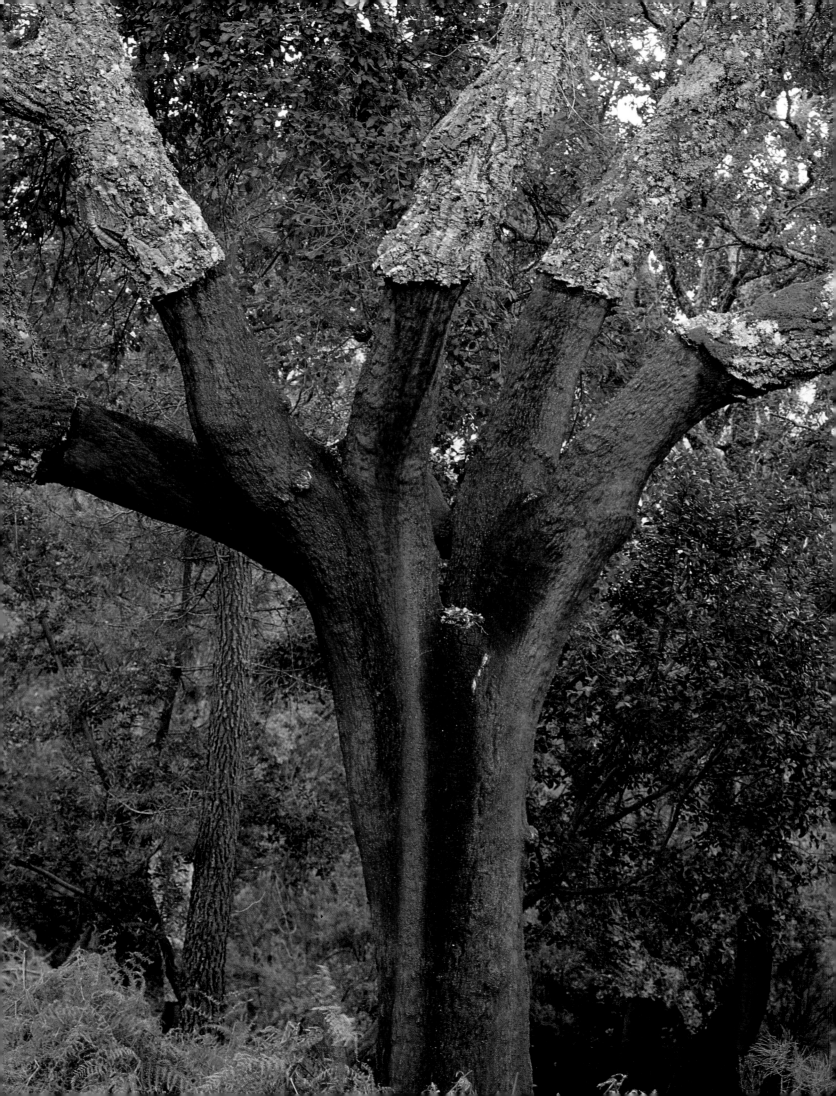

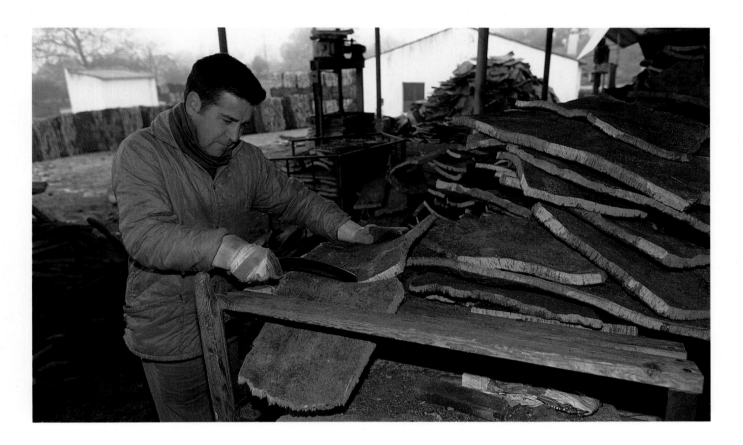

The Alcornocales nature reserve, in Cádiz province, includes one of the largest oak forests in Europe. The bark of cork oaks, which are also very common along the Portuguese border in the Sierra de Aracena, is stripped every eight to ten years.

• The cork oak •

A native of the Mediterranean area, the cork oak is a sun-loving, lime-hating species which thrives in cool soils. It is therefore found in mountain areas watered by streams and rivers, in the company of pines, evergreen oak, and scrub. It grows in most of Andalusia's nature reserves, such as the Sierra de Aracena, near Portugal, and the Los Alcornocales massif, in the province of Cádiz, which has one of the largest oak forests in Europe. The tree has twisted low branches crowned with foliage which is whitish on the underside, and it is the bark that provides the cork. The first layer of bark is harvested when the tree has reached 70 cm (28 in) in circumference. Depending on local custom, it is then removed at intervals of eight to ten years, and new trees are planted every 80 to 100 years.

• Bullfighting •

Variously regarded as an art form, a tragedy in three acts, and the ritual sacrifice of a brave animal to the greater glory of man, bullfighting still has plenty of *aficionados*. During the season, from early spring until late October, Spain's bullrings are as packed with spectators as its football grounds! Of course, the life-and-death struggle of the arena can hardly be compared with the very different style of the stadium. Before the fight, every *torero* is painfully aware of the fragility of his existence, seeing in his mind's eye the tragic end of such heroes as Manolete, gored in 1947, or more recently, Francisco Rivera. It is as vain to try to explain bullfighting as to criticize it. The Spanish have it in their blood. It has given rise to some fine writing, for instance the poem Federico García Lorca dedicated to the matador Ignacio Sánchez Méjías. The only way to appreciate the intensity of the spectacle is to attend a bullfight, witness the drama and excitement, sit on the terraces and experience the fear-laden silence, then rise in admiration to applaud a well-executed pass. Technically, the drama is staged in three acts, known as *tercios* or *suertes*: the *tercio de vara*, *tercio de banderillas*, and *tercio de muleta*. The president of the *corrida* (which consists of six fights lasting about 20 minutes each) sets the ritual in motion by waving a white handkerchief. The bull enters the ring. During the first *tercio*, the *torero*, in richly embroidered costume, uses a fuchsia-and-gold cape. Holding it in both hands, he performs a number of *verónicas*, passes in which the cape is swung slowly away from the charging bull. Assisted by fleet-footed *bandilleros* and mounted picadors, who goad the animal with their lances, he tests the vivacity and attitude of his adversary. During the second *tercio*, three pairs of *banderillas* (colourful darts) are planted in the bull's shoulders. The final act is the most poignant. Using his *muleta* (a smaller red-and-gold cape) the *torero* (now a matador) performs dangerous manoeuvres to draw the wounded animal closer to himself. He must then deal the death blow with a single thrust of the sword.

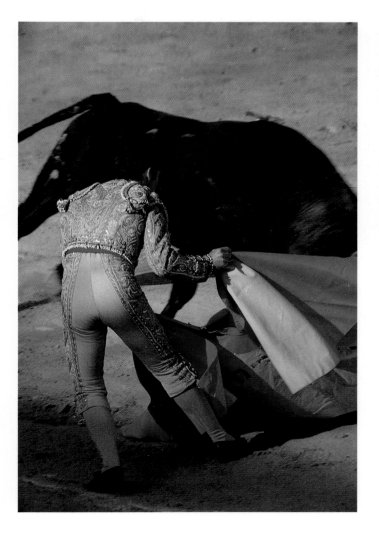

In the arena, the torero in richly embroidered costume makes skilful use of his muleta in playing the bull. Raised on stud farms, the animals destined for the arena are carefully selected for their fighting qualities.

The Costa de la Luz owes its name
to the burning purity of its light,
reflected by a sky without animosity.

THE ATLANTIC
Coast

The Costa de la Luz is a genuine surfer's paradise and is fortunate enough not to have fallen victim to the mushrooming of mass tourism. While the sportsmen enjoy the sun and sea, the fishermen of Tarifa or Zahara de Los Atunes dedicate themselves to their traditional calling.

From Tarifa, where it begins, to the Portuguese border at Ayamonte, the Costa de la Luz is a succession of dunes and wild marshes, mercifully spared the ravages of concrete and major roads. The coastline is whipped by an invigorating wind, for here Aeolus reigns supreme.

His restlessness is always evident at Tarifa, Europe's southernmost point, which turns its back on Gibraltar and its stormy strait. Riding above the salt spray, plunging clouds gallop above this last outpost of 15,000 people. Witnessing the marriage of Atlantic and Mediterranean waters, which clash and mix at its feet, Tarifa is also Spain's nearest approach to Africa: barely 13.5 km (8.5 miles) of sea separate it from the Rif Mountains of Morocco. Sculpting the ocean's mighty green rollers, the wind also attracts devotees of water sports, who flock to this surfers' Mecca to test their skills and daring. But in the town, huddled behind its Moorish ramparts, the sportsmen in fluorescent wetsuits do not impress the small community of local fishermen. They take to sea every day God gives, weather permitting, hoping to fill their nets with anchovies or sardines.

Similarly, to the north, their seagoing cousins at Zahara de los Atunes (2,900 inhabitants) barely turn their heads to observe the tourists who stray into their village. For generations, they have fished for tuna

(*atún*). Using the *madrague*, a net 5 km (3 miles) long, they perpetuate a tradition that dates back to antiquity. The art is to pen a shoal of tuna in a square enclosure, surrounded by the fishing boats. Weighing up to half a tonne, the huge beasts are finished off with harpoons in a bloody slaughter which might seem primitive and cruel. But this would be to underestimate the power of the fish, whose thrashing tail is quite capable of breaking the back of any unfortunate trying to deal the death blow – and to ignore the courage of these copper-faced men, who make their living along the 250 km (155 miles) of Andalusia's notoriously difficult Atlantic coast. They may appear uncouth, but are perfectly in tune with this thankless shoreline, from which famous navigators weighed anchor in quest of distant lands: Columbus, who set sail from the nearby port of Sanlúcar for the New World, and Magellan, who in 1519 left here on his first voyage of circumnavigation. At Sanlúcar itself, the muddy waters of the Guadalquivir collide with the ocean, churning up the shallows. Of the four original channels,

*I*n 1805, the combined
French-Spanish fleet sailed out
of Cádiz to suffer a crushing
defeat off Cape Trafalgar. But
Spain's enduring greatness is
reflected in these mosaics and
this monument in honour of
Christopher Columbus, who set
sail for America from Sanlúcar
de Barrameda.

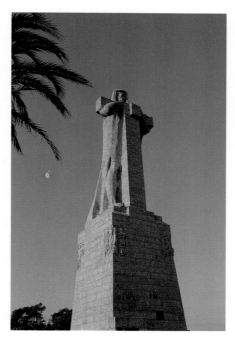

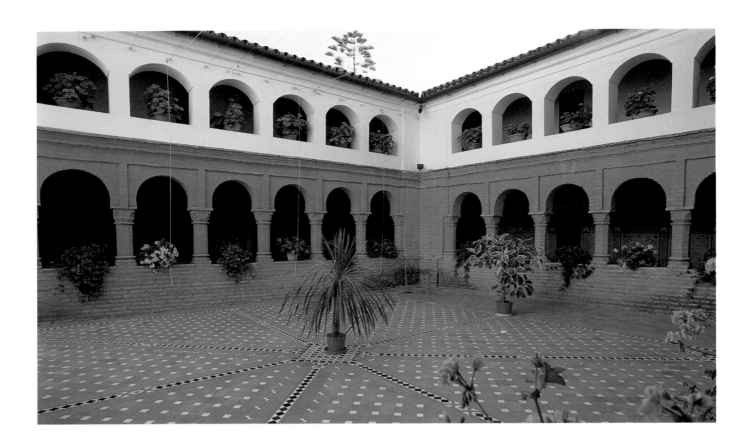

The isolated monastery of La Rábida, south of Huelva, with its mudéjar cloister, welcomed Christopher Columbus, and later the conquistadors Hernán Cortés and Francisco Pizarro.

only one remains, and that needs constant dredging to allow the prawn fishermen to negotiate the dangerous bar with its swirling silt. Of the 35,000 *sanluqueños* living in this amphibious environment, renowned for both sanctity and piracy, one stands out above all the rest: the Duchess of Medina-Sidonia. A descendant of the noble family which fitted out and provisioned the Indies fleet in the fifteenth century, Luisa Alvarez de Toledo was punished with prison and exile for her hostility to Franco's regime. When she raises her voice, people pay attention, and her anger has been well and truly aroused. The reason: the terrible disaster which struck the Doñana national park in April 1998. Hunting reserves that her grandfather had sold for a song were flooded with five million cubic metres (177 million cubic feet) of acid mud. A natural paradise was defiled by an ecological catastrophe which imperils mongoose, genet, lynx, migratory bird, and eel. The desecration, threatening 50,000 hectares (200 square miles) of scrub and sand dune where salt and fresh water mix, has shaken Andalusians to the core.

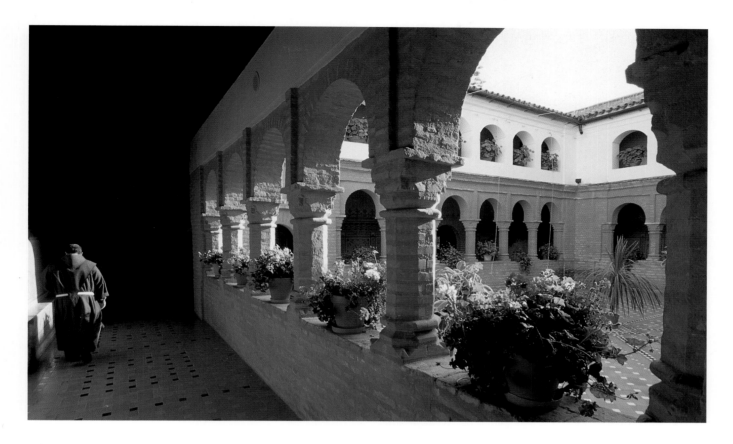

What can they do but offer up this wilderness, known best to the local village folk and the occasional poacher, to the mercy of the Virgin of Rocío – the sacred mother figure who protects both men and marshland? And hearing the prayers of the Whitsun pilgrims making their way to El Rocio, one can but hope for the resurrection of Europe's richest wildlife environment. The fact is that, despite recent efforts, Andalusia, like the rest of Spain, has paid little regard to conservation. Hard-working Cádiz is a place of desolate suburbs and depressed shipbuilding yards, where street urchins cast makeshift fishing lines into the torbid waters. The exception is the old town with its 158,000 inhabitants – an isolated rock joined to the mainland by a narrow isthmus. It is a wonder of a seaport, harbouring squares bright with flowers and eighteenth-century houses in the hollow of its ramparts, a port so perfect, yet so fragile, that it was easily conquered – pillaged in 1587 by the English sea-dog Francis Drake, and later bombarded by Nelson in 1797. Some go so far as to claim that the harbour was shaped

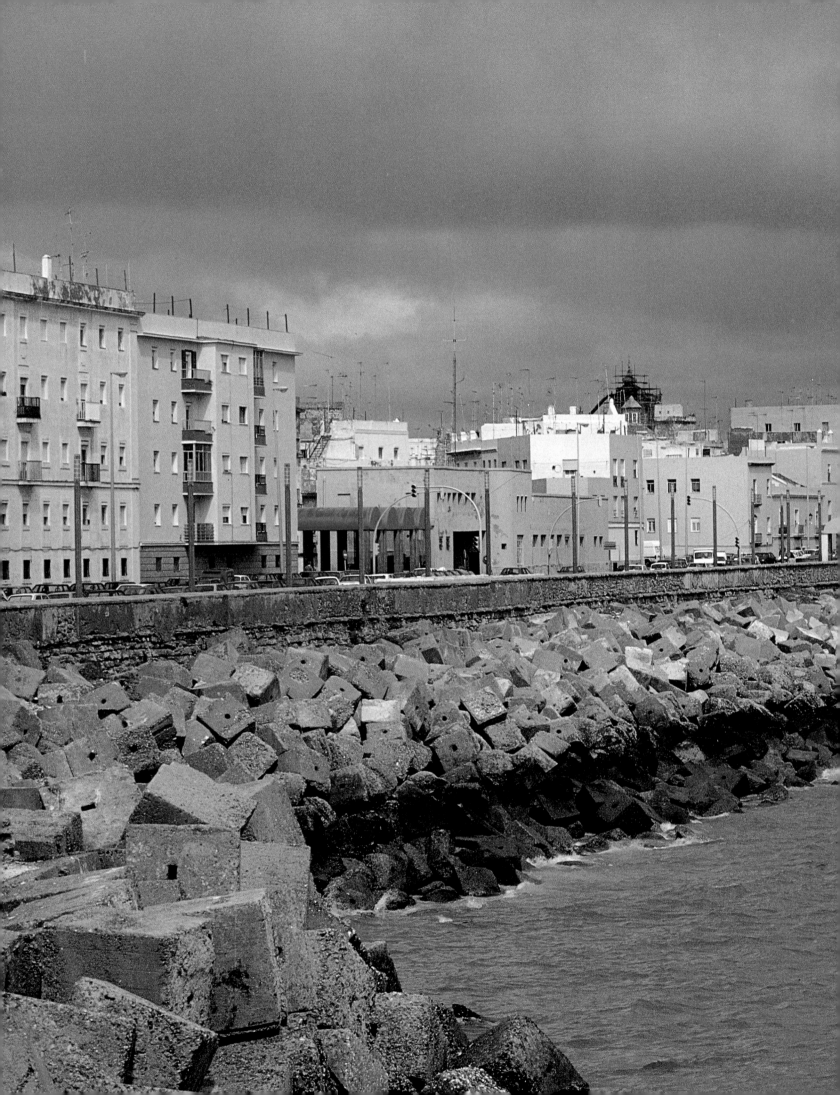

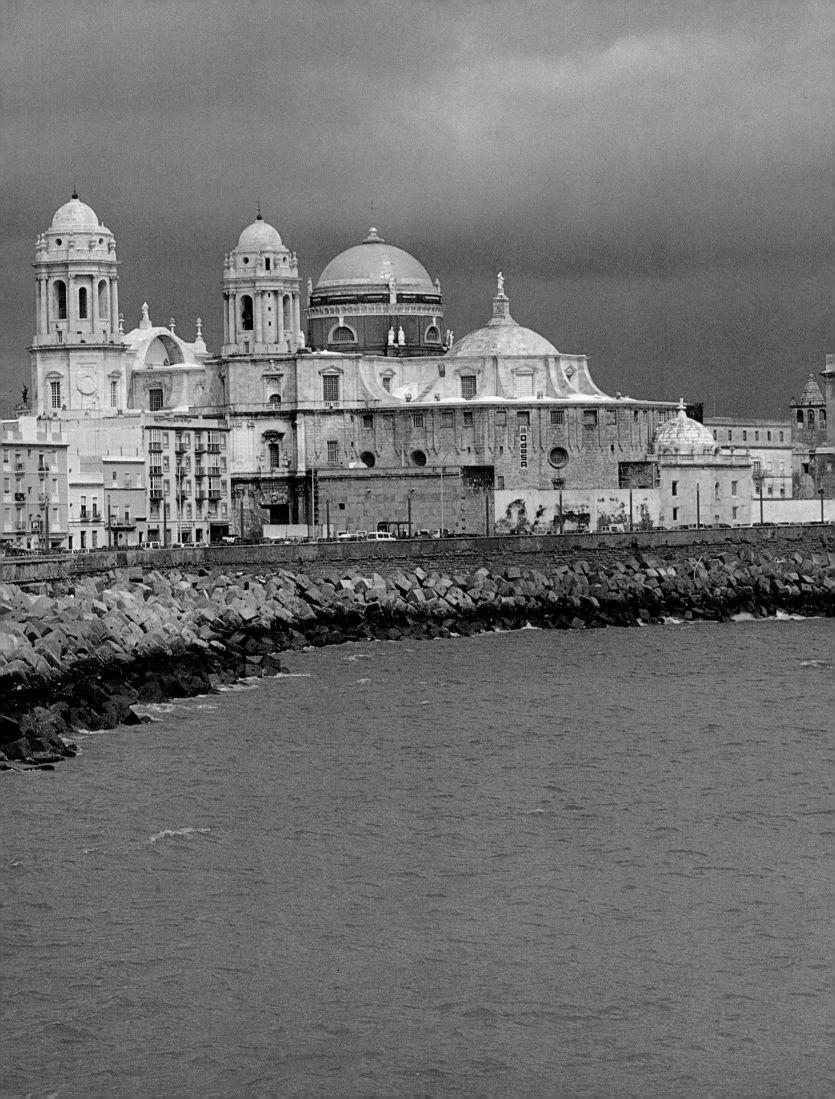

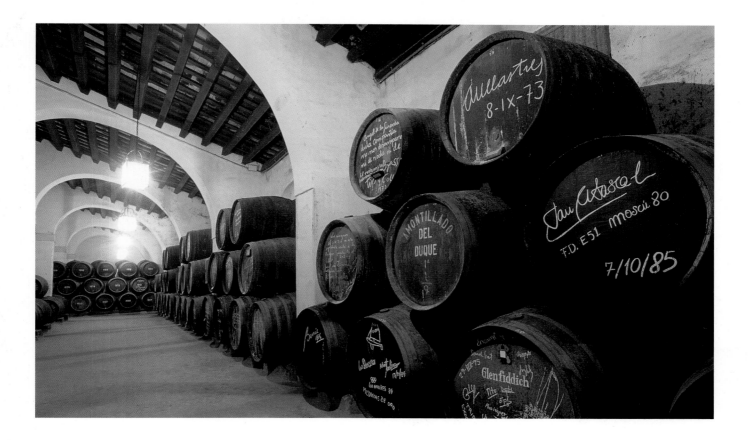

*W*ine and horses:
Life in Jerez has always been ordered around
these two prestigious commodities.

• The wines of Jerez •

A thousand years before Christ, the Phoenicians were already shipping hundreds of amphorae of wine from the port of Cádiz to all parts of the civilized world. Today, Andalusia's most celebrated wine is still produced in the triangle bounded by Sanlúcar, Jerez, and Puerto de Santa María. It is variously known as Jerez, Xerès, and sherry. Scorched brown in the salty air of the coastal strip, the vines yield a grape with a seagoing flavour. For four or five years, the nectar is aged in hand-made American oak casks holding 550 litres (around 120 gallons). The golden Fino and pale yellow Manzanilla are light, dry wines, and must be drunk in the shade. The Oloroso is stronger and fuller-bodied, so beware! Lastly, there is the tender Moscatel, whose sweetness is best enjoyed during an intimate *tête-à-tête*.

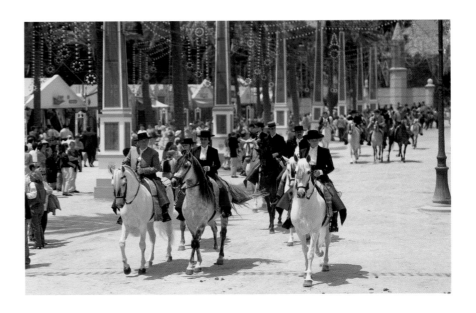

*T*he annual feria del caballo is held in late April and early May. There is a horseback procession celebrating the royal stud farm at Jerez and the sixteenth-century crossing of two Andalusian breeds, which gave rise to the superb horses of today. Jerez's most prestigious institution, the Royal Riding School, directed by Alvaro Domecq, puts on fabulous equestrian displays.

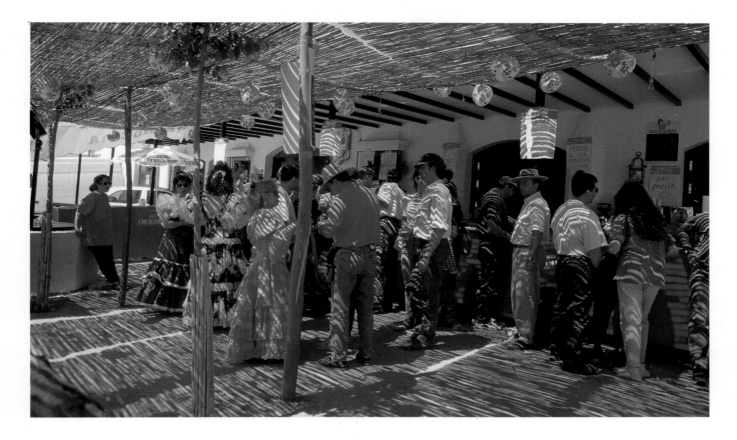

by Hercules himself. From its past, Cádiz has inherited a cathedral which guards the tomb of the composer Manuel de Falla, and a maze of narrow streets and terraces.

Cádiz and its carnival are the best-known aspects of Andalusia's Atlantic seaboard. But this region really owes its identity to the horse. For centuries, this lordly creature has grown to strength in the plains of Jerez de la Frontera and rubbed shoulders with death in the arena. A man who has fallen madly in love with the proud beast is Alvaro Domecq, whose family made their fortune in the wine trade. He won his spurs raising bulls and thoroughbreds on the 700 hectares (2.8 square miles) of his *finca*. In Jerez, he directs his very own Royal School of Equestrian Arts, granted the royal privilege in 1987 by King Juan Carlos. It is his masterpiece, equalled in Europe only by Saumur and Vienna. The honour is shared by the whole of Andalusia, for evident in the nobility of these magnificent horses is the quality which more than any other drives its people: pride.

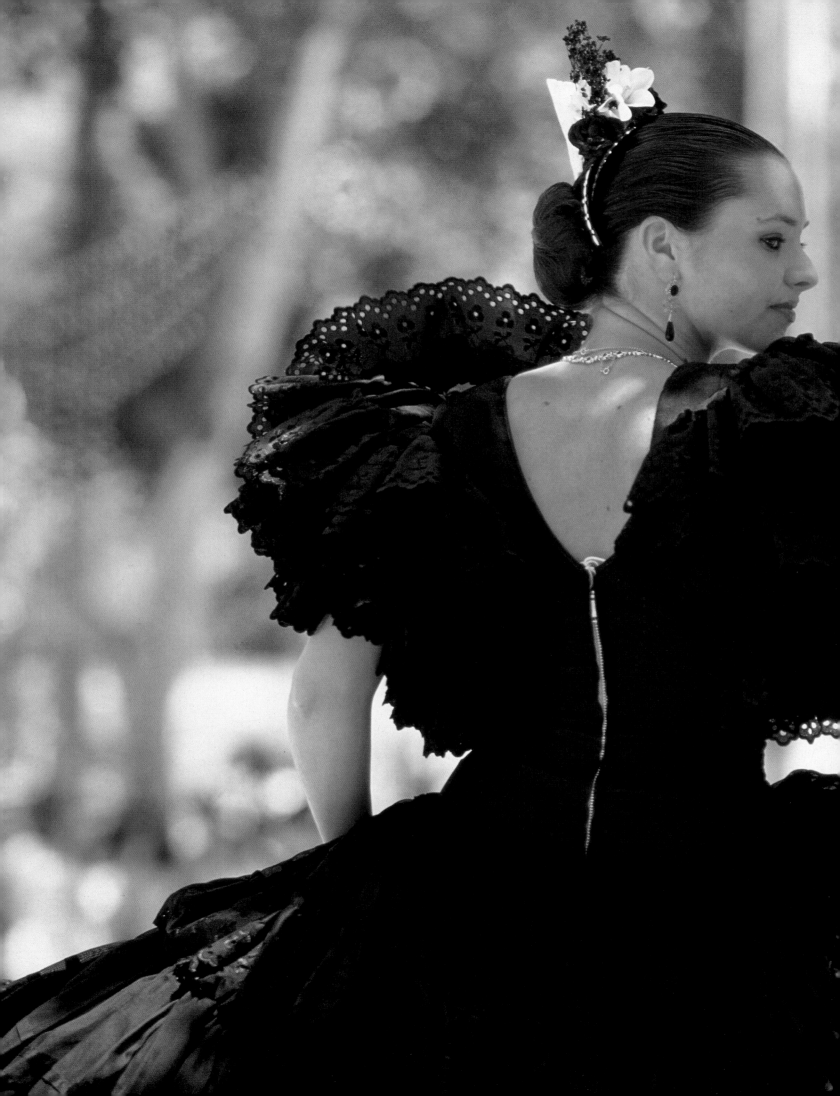

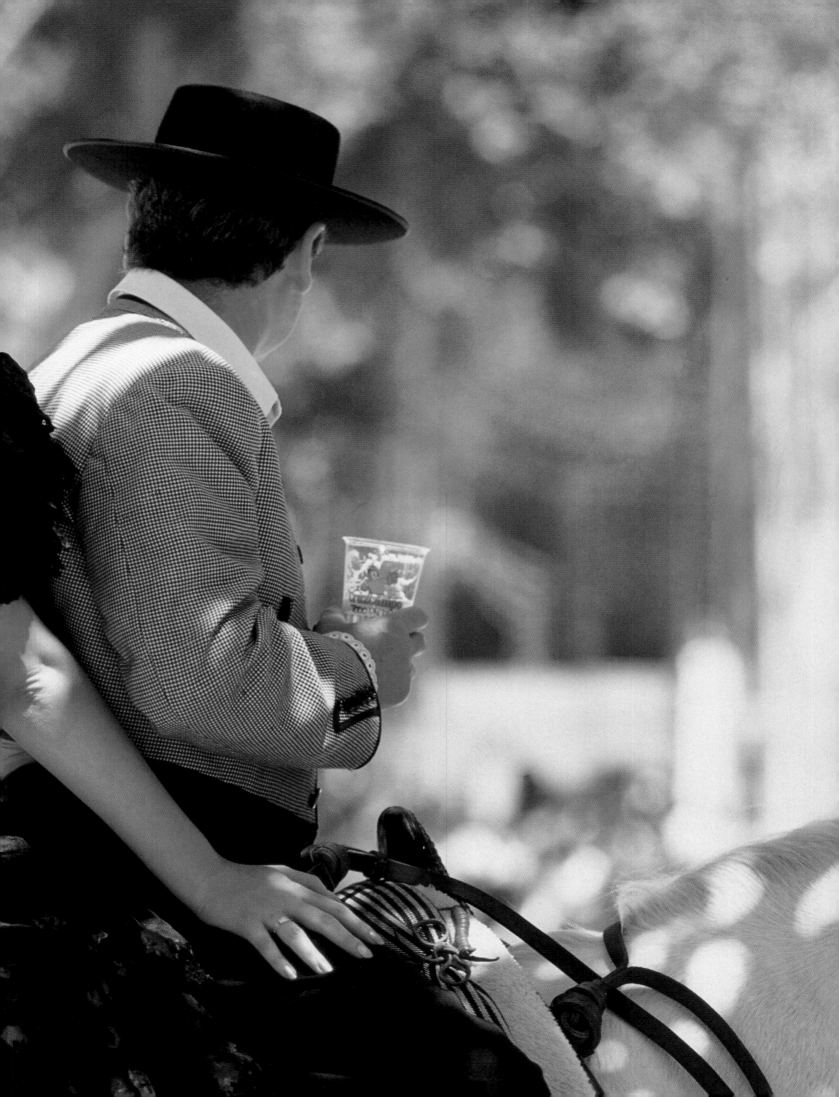

USEFUL INFORMATION

TOURIST INFORMATION IN THE UK: Spanish Tourist Office, 22-23 Manchester Square, London W1M 5AP; tel. 0171 486 8077, fax 0171 486 8034. Internet: www.tourspain.es.

TOURIST INFORMATION IN ANDALUSIA: Oficina de Turismo, Avda. de la Constitución 21, 41004 Sevilla; tel. (0034 95) 4221404, or Corral del Carbón, 18009 Granada C.P.; tel. (0034 958) 225990, fax (0034 958) 223927. There are also tourist information offices in all the main towns and cities.

ENTRY AND CUSTOMS FORMALITIES: A valid passport is all you need as UK citizens do not require visas. There are no restrictions on the import and export of items for personal use.

SPANISH EMBASSY IN THE UK: 24 Belgrave Square, London SW1X 8QA; tel. 0171 235 5555, fax 0171 259 5392. Consulate: 20 Draycott Place, London SW3 2RZ; tel. 0171 589 8989, fax 0171 581 7888.

BRITISH CONSULATES IN ANDALUSIA: Málaga: Edificio Duquesa, c/Duquesa de Parcent 8, 28001 Málaga; tel. (0034 95) 221 7571, fax (0034 95) 222 1130. Seville: Plaza Nueva 8B, 41001 Sevilla; tel. (0034 95) 422 8875, fax (0034 95) 421 0323.

MONEY: The currency is the peseta (pta), of which there were 240 to the pound in February 1999. Spain is also part of the euro zone, and euros will be used for non-cash transactions until the introduction of euro notes and coins in January 2002. Cashpoint machines are widespread, and all major credit cards are widely accepted.

GETTING TO ANDALUSIA: Spain's national airline is Iberia, whose London reservations and ticketing office is at 27–29 Glasshouse Street, London W1R 6JU; tel. 0171 830 0011, fax 0171 413 1262. The airline operates direct flights to Málaga and Seville, and flights to Almería and Jerez de la Frontera via Madrid or Barcelona. Numerous other scheduled and charter airlines serve Málaga, and the flight time is around 2 hours 20 minutes.
By train, the fastest journey time from London Waterloo to Madrid is around 17 hours. From there, the AVE high-speed train to Seville takes 2½ hours, with departures several times a day.

THE REGION AND THE PEOPLE

GEOGRAPHY: Andalusia is in the south of the Iberian peninsula, and its southernmost point is only 13.5 km (8 miles) from Africa. It has more than 800 km (500 miles) of Mediterranean and Atlantic coastline, and consists of eight provinces, with widely varying landscapes. The Sierra Morena mountain range in the north has many nature reserves, while to the southwest is the wide, fertile plain of the Guadalquivir, which flows into the Atlantic through Seville, Huelva, and Cádiz. The Sierra Nevada, part of the Baetic Cordillera, contains Spain's highest mountain, the 3,478-m (11,410-ft) Mulhacén.

SURFACE AREA: Around 88,000 km² (34,000 sq. miles), slightly smaller than neighbouring Portugal and about a third the size of Great Britain.

CAPITAL: Seville, with a population of over 700,000.

FORM OF GOVERNMENT: Andalusia has been one of Spain's seventeen autonomous regions since 1981, and has its own parliament.

ECONOMY: Andalusia is Spain's leading agricultural region; farming and tourism are its two main sources of income. Crops include olives, sherry, cereals, rice, and citrus fruit.

CLIMATE: The region has a Mediterranean climate with hot, dry summers, mild winters, and low rainfall; temperatures in the interior are more extreme than on the coast. The best times to visit Andalusia are spring and autumn.

LOCAL TIME: One hour ahead of GMT.

POPULATION: Seven million.

RELIGION: Ninety-five percent of Andalusians are catholics.

TOURIST ATTRACTIONS: The most distinctive building in SEVILLE is the GIRALDA, a 12th-century minaret just over 100 metres (330 feet) high. Giralda means "weathervane", and the tower

takes its name from a 4-metre (13-foot) figure of a woman on the top which turns in the wind. Beside it is SANTA MARÍA DE LA SEDE, one of the world's great cathedrals, whose main attraction is the 23 x 20-metre (75 x 66-foot) altarpiece. The ALCÁZAR is a fortified palace built by Peter the Cruel in the fourteenth century, a jewel of Moorish art and Europe's oldest royal palace. It has an archive of precious manuscripts and some 7,000 maps from the time of the Spanish exploration of America. The TORRE DEL ORO, once covered in gold leaf, is now a shipping museum. The ruined Roman city of ITÁLICA, with its well preserved amphitheatre and very fine mosaics, is a few kilometres outside Seville.

In CÓRDOBA, the eighth-century MEZQUITA or Great Mosque is a UNESCO world heritage site. A cathedral with around a thousand pillars was built inside it after the Moors were driven out of Spain. The KING'S FOUNTAIN in PRIEGO DE CÓRDOBA is one of Andalusia's most beautiful fountains, and the ruins of the tenth-century caliphs' city of MEDINA AZAHARA are about 8 km (5 miles) west of Córdoba.

JAÉN is the capital of the "olive province" of the same name; its eleventh-century Arab baths are worth seeing. The LIONS' SQUARE in BAEZA has an ancient fountain decorated with four stone lions.

GRANADA, at the foot of the Sierra Nevada, was the last bastion of the Moors. It is the home of the internationally renowned ALHAMBRA PALACE (its name means "the red"), another UNESCO world heritage site. The highlight of this complex is the COURT OF THE LIONS, decorated in filigree with twelve marble lions spouting water. Granada's cathedral is also regarded as the finest renaissance church in the world.

In the cave town of GUADIX, brilliant white houses stand out against the brownish sandstone rocks. High above Picasso's native city of MÁLAGA, a walled path connects the fortress of Gibralfaro with the fortified upper town. Málaga's cathedral is called "the one-armed" because it was never completed and has only one tower.

RONDA stands on two steep cliffs separated by a canyon 200 metres (700 feet) deep. In the nature reserve of EL TORCAL DE ANTEQUERA, wind and water have carved the rocks into bizarre formations. ALMERÍA, in the east, is Andalusia's desert province, and Europe's biggest solar energy plants are located near the town of TABERNAS. Another sight worth seeing on the coast is the volcanic nature reserve of CABO DE GATA.

CÁDIZ lies in a sheltered bay on a rocky plateau overlooking the Atlantic, and is believed to be Europe's oldest settlement. DONAÑA NATIONAL PARK, in the Guadalquivir delta, is Europe's most important haven for birds and has been declared a biosphere reserve by UNESCO.

TRANSPORT: Andalusia has an extensive system of highways, and car rental companies have offices in most towns, cities and airports. There are very good long-distance buses, and rail links between main towns and cities. The daily Talgo 200 train connects Córdoba to Cádiz in only just over three hours, while the Al Andalus Expreso hotel train provides a particularly comfortable way of crossing the region. Taxis are very cheap, and longer-distance fares are open to negotiation.

CUISINE: Many bars serve tapas – a selection of hors d'oeuvres – at lunchtime and in the evening; these are often drunk with sherry. Fried, boiled and marinated fish are ubiquitous in restaurants near the coast, and paella (rice with seafood) and gazpacho (cold soup made from tomatoes, peppers and other ingredients) are also served in many restaurants. Further inland, rabbit and pork stews are popular dishes.

Although all information was carefully checked at the time of going to press (February 1999), the publisher cannot accept responsibility for its accuracy.